Images of Modern America

THE BALTIMORE & OHIO RAILROAD'S PITTSBURGH DIVISION

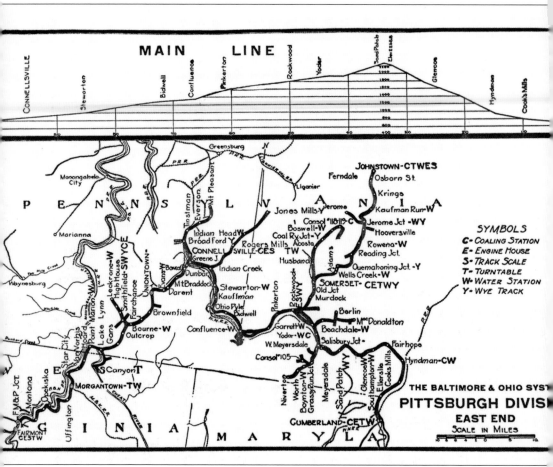

This map shows the routes composing the Pittsburgh Division of the Baltimore & Ohio Railroad. (Author's collection.)

FRONT COVER: This was the excursion train on the morning of September 13, 1986, crossing the Monongahela River at Fairmont, West Virginia. This was the last passenger train the Fairmont, Morgantown & Pittsburgh (FM&P) would ever see. The bridge and track were still physically in place as of 2015, but they were nowhere near in the kind of condition seen here. (Author's collection.)

UPPER BACK COVER: This eastbound Extra No. 4177 with the *Philadelphia Trailer Jet* is running at track speed, but because the train is on a descending grade, it was virtually silent. Had it not been for the grade crossing signal in the background, the train's presence may have gone undetected. (Author's collection.)

LOWER BACK COVER (from left to right): Extra No. 3760 eastbound at Ellerslie, Maryland, in January 1980 at the Forest Grove grade crossing (Author's collection); a motorcar is on its last legs in October 1978 (Author's collection); operator Jay Baer at the helm of the armstrong interlocking plant in Q Tower on January 31, 1987 (Author's collection).

Images of Modern America

THE BALTIMORE & OHIO RAILROAD'S PITTSBURGH DIVISION

Bruce Elliott

ARCADIA
PUBLISHING

Published by Arcadia Publishing
Charleston, South Carolina

Printed in the United States of America

Library of Congress Control Number: 2016933300

For all general information, please contact Arcadia Publishing:
Telephone 843-853-2070
Fax 843-853-0044
E-mail sales@arcadiapublishing.com
For customer service and orders:
Toll-Free 1-888-313-2665

Visit us on the Internet at www.arcadiapublishing.com

CONTENTS

ACKNOWLEDGMENTS

I give the Lord all the praise for giving me good health and a steady job and keeping me safe while out taking photographs over the years. These things should not be taken lightly. These are blessings, and I feel blessed to share these images and stories with you! I would like to thank my parents, who were always tolerant of a boy who loved trains, both models and the prototype. I grew up in Bethesda, Maryland, and the only game in town was the Baltimore & Ohio (B&O). My father was a very good amateur photographer who enjoyed what could be called industrial photography; he especially liked to photograph trains. We started to travel to places like Point of Rocks and Brunswick, Maryland, and to Martinsburg, West Virginia. It was no surprise that I fell in love with the B&O. My first favorite book was *B&O Power*, by Alvin Stauffer and Larry Sagle. I would pore through the pages studying the photographs from all over the system. My high school graduation present was a 35mm Nikon camera.

My inspiration was the many photographs taken by photographers who, like me, spent countless and tireless hours capturing the railroad at that time in history.

In 1986, I joined the Baltimore & Ohio Railroad Historical Society (B&ORRHS). This was one of the best railroad-oriented ideas that I ever had. The wealth of knowledge of the membership that they are always ready and willing to share is second to none. A great deal of thanks goes to Harry Meem, the past editor of the *B&O Sentinel*, for his help in editing this book. For the last five years, I have been on the board of directors and am now the modeling committee chairman for the society. I have been a model railroader for the past 63 years, I have modeled in HO Scale for the past 55 years and modeled the B&O for the past 41 years. There would be literally dozens of pages of people to give credit to for my interest in the B&O, but I never took the time to write down their names. One thing I can truthfully say about the B&O is that, in two and a half decades of photographing the railroad, I was never asked what I was doing or who gave me permission and was never greeted in an unfriendly manner. I believe that that was in part because I respected the railroad and the ever-present danger that it poses. Common sense kept me from going where I knew I could not go, like inside major shop complexes, but even these locations were hurdles that were overcome when the members of B&ORRHS would go on their annual convention to various locations around the system, which opened doors that were closed to me as an individual.

The photographs in this book are all from my own collection and pulled from over 450 photographs of the Pittsburgh Division. Each chapter's photographs are in geographic order, from the beginning of the division to the end. There are some holes in my coverage, and for that, I am sorry for both of us, but I was able to cover a lot of locations, many of which were obscure names on a timetable only. A vast majority of the photographs on these pages are of scenes, yards, structures, rolling stock, and locomotives that are now only fond memories.

WHEN EAST ISN'T EAST: On the Baltimore & Ohio Railroad, all trains proceeding away from Baltimore were considered to be westbound, no matter what geography dictated. Thus, trains from Pittsburgh to Buffalo (chapter 3) were westbound, even when running north, and things could really get confusing on the FM&P (chapter 5), where a subdivision that started in Fairmont, West Virginia, carried trains railroad-westbound to Connellsville, Pennsylvania, some 70 miles to the northeast.

We will try in the captions to make the directions clear; when in doubt, assume "east is east" in the geographic (rather than the railroad) sense.

INTRODUCTION

The Pittsburgh Division of the B&O Railroad began as early as 1837, but it would be many decades before the main line would be completed between Cumberland and Pittsburgh and all would fall under the control of the B&O. In much the same way that the B&O tried to keep its rival, the Pennsylvania Railroad (PRR), out of Maryland, so too, the PRR tried to keep the B&O out of Pittsburgh. A route to Pittsburgh and the Ohio River was the initial goal of the B&O Charter, but it was thwarted by the PRR in the Pennsylvania State Legislature, thus Wheeling, Virginia, became the initial western terminus of the railroad.

The route that the early predecessor railroads chose was perhaps the best route overall, but these companies' finances were meager, to say the least. When the connection was finally completed, it was absolutely nothing like what existed by the middle of the 20th century when your author came around. It was initially a single-track line that was, by today's standards, poorly constructed. While it provided quicker access between destination points, 15 to 20 miles per hour was considered high speed.

In the mid-1950s, the Pittsburgh Division consisted of many subdivisions, including trackage rights over the Western Maryland between Viaduct Junction in Cumberland, Maryland, and Mount Savage Junction where the B&O Main Line started, continuing to Grant Street station in downtown Pittsburgh. Then there were the Pittsburgh & Western (P&W); the Somerset & Cambria (S&C); the Fairmont, Morgantown & Pittsburgh (FM&P); the Fayette County Branch; and the Wheeling, Pittsburgh & Baltimore (WP&B) lines. Other subdivisions of the Pittsburgh Division included the following: the Salisbury Branch, the Berlin Branch, the Quemahoning Branch, Wilson Creek Branch, the Coleman Branch, the Jerome Branch, the Fort Hill Low Grade Line, the Adamsburg Branch, the Indian Creek Valley, Mount Pleasant and Broadford Branch, the Cheat Haven & Bruceton, the Tylerdale Connecting, the Sugar Creek Branch, the P&W's River Branch, and Allegheny Yards. Through freight and passenger trains enjoyed trackage rights over the Pittsburgh & Lake Erie, bypassing the more arduous P&W subdivision. Many of these subdivisions had disappeared by the time your author had the means to photograph them. Had the railroad and the opportunity been available, there would be at least two more books on the Pittsburgh Division to follow.

I spent a little over 15 years photographing the Pittsburgh Division. All in all, there were very few things that came up that were special, or different. Many people would probably consider most of what I did unusual, but for me it was rather routine. Technically, I was trespassing while photographing the railroad. However, I was doing it safely and respectfully—truthfully, that is a lie. Basically, in an effort to get some of the photographs in this book, I had to go out on a limb, so to speak. In some cases, you will notice that I am not exactly on the ground or on a locomotive. If what I considered a good photograph meant that I had to climb on a freight car, hang from a bridge, climb a block signal, or walk through a tunnel, well, so be it. Often, it was a lot of walking for hours, from the car to some remote locations just to get one photograph. Even though it became sort of routine, I really relished the opportunity to get a cab ride.

While I was dating my wife-to-be, I spent time at the tower at Hyndman, Pennsylvania, literally every Saturday for months. It was not long before the tower operator was making arrangements with helper crews for me to ride with them "up the hill." On one occasion, the day before hunting season was to start, we left Hyndman in the evening. By the time we got to Mance, it was dark. The fireman asked me if I wanted to see some deer. He had rigged up a spotlight from a used locomotive headlight, and when we got to the Horseshoe Curve there at Mance, he turned it on the field. There was literally a sea of eyes. I had never seen that many deer in my life! It seemed like every deer in Somerset County was in that field grazing. The fireman said to me, "You know,

tomorrow you won't find a deer there for the next month or more because of huntin' season." Not that I doubted him, but sure enough, the next time I had an opportunity to go up the hill, the field was bare. After that trip, I always anticipated seeing the field there at Mance, remembering what seemed like hundreds of eyes reflecting back at me.

In the fall of 1985, Sand Patch fell victim to an abnormal amount of rain that devastated the Potomac River valley. A flood of water poured down Wills Creek and on to Cumberland. A wide gash was cut out of the river bank at a location the railroad called Brackens Curve. This was not the first time this had happened, as years earlier, in an attempt to control the water, the railroad had built walls along Wills Creek here. The Chicago Line and the St. Louis Line were severed and would be for several weeks. I felt privileged to be able to "ride the hill" shortly after the No. 1 track was restored.

It would still be a couple of weeks before the No. 2 track was restored. A 10-foot wall of water came through Hyndman, most of it contained within the width of Wills Creek at that point. Most of the fill that was used to restore the right-of-way for the railroad came from across Wills Creek. Time is an interesting thing, and the signs of that are gone; it is amazing how 30 years can change the appearance of a scarred hillside and creek bed.

I was always a little sad when a train went by, because I could not be on it. I knew it would go somewhere I had not been before. Back in the days of steam, I would travel to locations that I had seen in books, and it was disheartening to see how progress had robbed the yards, stations, branch lines, and employees of the business that I had seen in books from the golden age of trains.

Getting my driver's license opened up a whole new world, and job employment kept me in money to buy gas and film to expand my photographic trek over the B&O. My career job with the Washington Metropolitan Area Transit Authority started in 1975. By the late 1970s, I was becoming painfully aware that the B&O that I had admired in books was slowly going away. To that end, I decided to make the best effort that I could to photograph what was left of the B&O. By the late 1980s, I had amassed 8,000 photographs of the railroad from Wilmington, Delaware, to both Chicago and St. Louis, and a huge number of places in between. While I was not able to photograph it all, I am satisfied that I was able to get possibly the best education on the B&O, where it ran, how it operated, and what it looked like in the twilight years, that my money could buy.

On a trip one summer afternoon on a Saturday going "up the hill," we were on the rear of a Trailer Jet, and when we came out of the west portal of Falls Cut tunnel, the tracks cross over Wills Creek on a bridge. There were at least a dozen young adults that were mostly in the water. The fireman said to me, "You know what they're doin', don't you?" Silly me, I replied, "Swimming?" He said, "Well we'll see when we come back down, but I think they're skinny dippin'." So, on our way down the hill, the engineer cut off the locomotive at Foley, and we were coasting down the grade. Now let me tell you, trains can be as silent as the grave, and sneak up on you before you know that they are there. That was exactly what happened. When we went over the bridge, the following two things were evident: no one had any clothes on and everyone was surprised! Believe it or not, I was so intent to see if the fireman was right that I forgot to get the camera ready.

After World War II, when the country started to move away from coal and looked to the newer sources for energy that were cleaner and just as efficient to use, the railroad was able to find other sources for revenue including the transport of these new energy sources. Today, intermodal traffic is the big factor on the Pittsburgh Division, with CSX investing millions in the "Gateway" Project that will allow double-stack intermodal trains to travel from the Midwest. Amtrak operates the *Capitol Limited* daily over this route between Washington, DC, and Chicago, and the section from Washington to Pittsburgh is over the former B&O.

One

THE MAIN LINE EAST SLOPE

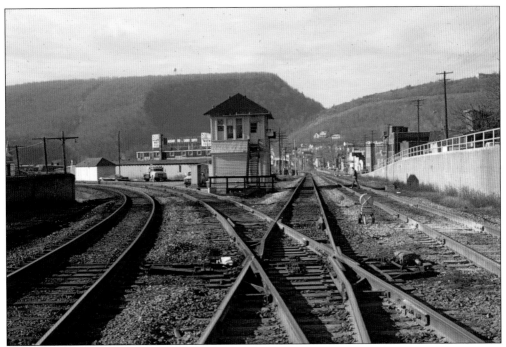

The east slope of Sand Patch grade starts here, at ND Tower at Viaduct Junction in Cumberland, Maryland, and ends at the west portal of Sand Patch tunnel. On the B&O, this is one of the more famous grades in the railroads' assault on the Allegheny Mountains. Compared to the west slope, it is so short and steep that the railroad required a helper station at Hyndman, Pennsylvania, to get westbound trains over the top. The PRR is known for Horseshoe curve. The B&O has its own Horseshoe curve at Mance, Pennsylvania; though only two tracks, it is every bit as important and impressive as its PRR counterpart. CSX and Amtrak wrestle with this today, just as the B&O did for decades before them. Though long gone today, interlocking towers dotted the hill at strategic points to control traffic. Today, there are only two tracks on the hill. This is the beginning, or east end, of the Pittsburgh Division, the tracks straight ahead. The two tracks to the left of this tower are part of the Cumberland Division. The interlocking plant was controlled by an armstrong interlocking mechanism. All immediate switches were thrown from inside the tower. Old US Highway 40 is located above the concrete retaining wall to the right. This photograph was taken January 21, 1973.

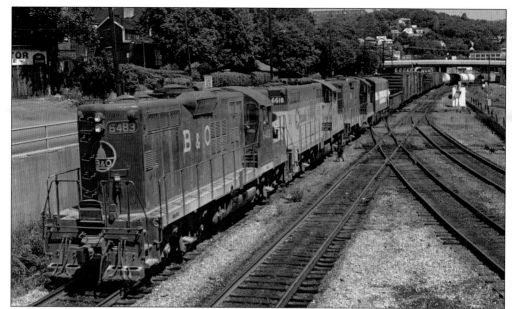

In June 1978, GP-9 No. 6483 and a steam generator–equipped GP-9, No. 6618, lead two Western Maryland–lettered units through Viaduct Junction with a westbound train headed to Connellsville, Pennsylvania. To the left of the lead locomotive, in this photograph from the second floor of ND Tower, you can see old US Highway 40, and the overhead bridge in the background is Frederick Street.

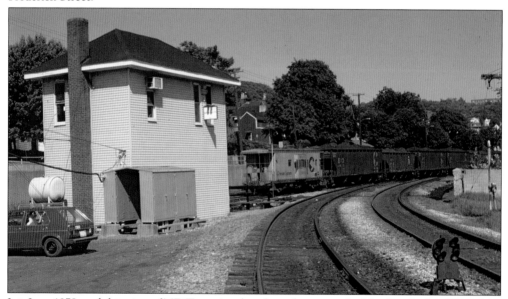

It is June 1978, and this view of ND Tower is taken from the east end of the Cumberland Division's West End. Chessie has recently modernized the tower's appearance with new siding and fewer windows. Note the double bank of relay boxes in the left front of the tower. A red dwarf signal in the foreground indicates that switches are thrown against any eastbound train movement from the West End. GP-30 No. 6961 was in the lead of this eastbound coal drag that was en route to Curtis Bay, Baltimore. Caboose C-3810, a Class C-26, is shown here bringing up "the markers" (end-of-train marker lights) as the train arrives in Cumberland, Maryland.

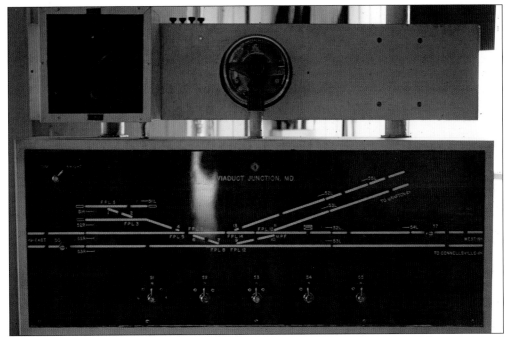

On a trip to Cumberland on March 15, 1986, I finally got the nerve to go inside ND Tower. I realized that a lot of what I had taken for granted over the years about the railroad was, in all probability, going to go away. This photograph shows what some call a "model board," an electronic diagram of the main tracks controlled by the tower operator. From this panel, traffic was routed east to Baltimore and west to Grafton and Pittsburgh. Tracks to the left of center show the main tracks entering the massive Cumberland yards, the tracks in the upper right are heading to Grafton and St. Louis, and the lower-right tracks are going to Connellsville and Chicago.

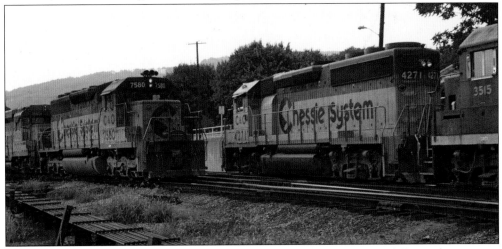

On August 16, 1986, I was able to capture two trains, on two divisions in different directions at Viaduct Junction. Extra No. 7580 is eastbound, coming off the Cumberland Division's West End with a coal drag from Grafton, and is entering the Cumberland Division East End and Cumberland yards. Extra No. 4271 is headed west, entering the Pittsburgh Division, with a long string of empty coal cars headed back to the mines. Most railfans live for such photographic opportunities; I was just at the right place at the right time.

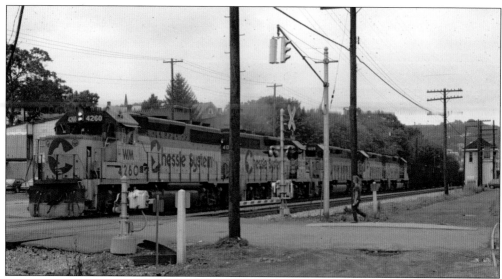

On June 28, 1986, I was at Knox Street, the first grade crossing west of Viaduct Junction, as Extra No. 4260 West was approaching with a westbound load of iron ore. Most likely, the train originated at the Curtis Bay yards in Baltimore and was headed west for a steel mill, perhaps in Pittsburgh, Youngstown, or in the Chicago area on the southeast side. The extreme weight of the train dictated the extra power up front, as there is 15,000 horsepower shown, and there will no doubt be at least another 6,000 horsepower added at Hyndman to get the train up and over Sand Patch.

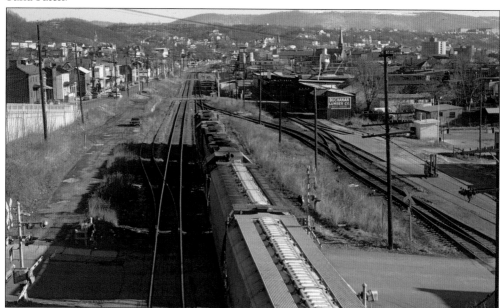

On January 9, 1976, from the US Highway 40 overpass, I caught an eastbound grain train crossing over Franklin Street. Its final destination was the Locust Point yards in Baltimore, Maryland. The Buchanan Lumber Company yards are at the right. The siding at the left was a "team" track for local businesses on the west end of town. About 20 years earlier, my father photographed a Western Maryland "local" switching on that track with a steam locomotive. The red 1969 Camaro adjacent to the team track was my everyday transportation at the time.

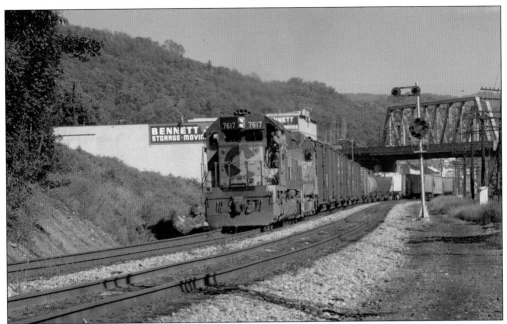

Gently easing under US Highway 40 and past the Bennett Transfer Co. warehouse, we find Extra No. 7617 and an unidentified GP-30 westbound on September 6, 1986. It must have been a hot day, as one of the crew has opted to get a little fresh air as the train enters the Narrows. The red block signal indicates that tracks at Viaduct Junction are yet to be aligned.

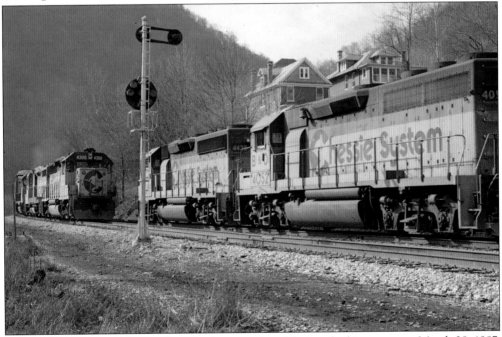

This photograph was taken at the same location, but this time looking west, on March 28, 1987. No. 4425 is on the point of the westbound *Queen City Flyer*, with No. 4052 assisting. Eastbound, we have Extra No. 4300 on the point of a Baltimore-bound freight. This is another photograph of opportunity, as both trains are moving and in the right place at the right time.

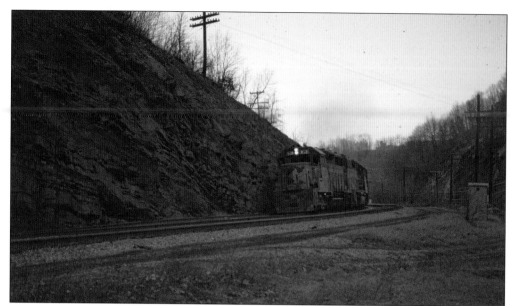

This location is called "Red Rock," and aptly so, as these rocks have a decidedly reddish brown tint. On March 7, 1987, in the early evening, we see Extra No. 3535 west, entering the Narrows. To the right of the train is a concrete telephone booth used by the railroad. To the right of the telephone booth is Wills Creek, and on the other side of Wills Creek are old US Highway 40 and the Western Maryland Railroad to Connellsville. It is a narrow passage through the mountain, with a lot of traffic. In the early part of the 20th century, there was also a trolley line on this route.

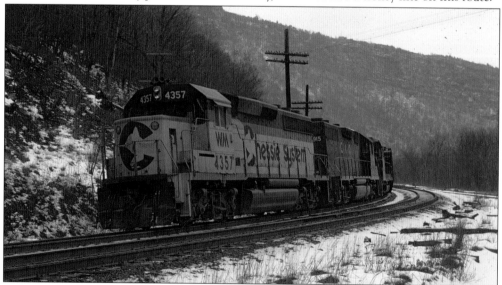

We are at Eckhart Junction, located at the west end of the Narrows. Lovers Leap, which was named after a local Native American legend, is on the ridge in the distance. Here, we see Extra No. 4357 on a westbound about to pass under Western Maryland's State Line Branch. To the right, the track is also part of the Western Maryland line to LaVale, Maryland. Though many people consider the trackage from Viaduct Junction to Eckhart Junction to belong to the B&O, in truth, the B&O exercised trackage rights between the two locations with the Western Maryland Railroad. B&O trackage started from just in front of the locomotive.

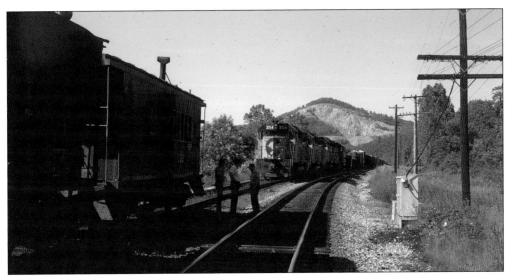

There are days when traffic just comes to a standstill, and this was one of them. On a summer day in June 1978, at milepost No. 180.6, we find the end of one eastbound train with C-3781 bringing up the markers, and Extra No. 3714 is literally within a stone's throw of the first train. They are waiting their turn to get into the Cumberland yards. Hopefully, they will reach the yard before their train becomes "outlawed," due to time on the road. The first train's head end was waiting at the block signal located just west of the US Highway 40 bridge. Meets like this were very rare. Usually, trains would have a minimum of a block located between them, and when operating, three blocks. In the background is a stone quarry, located near Mount Savage Junction.

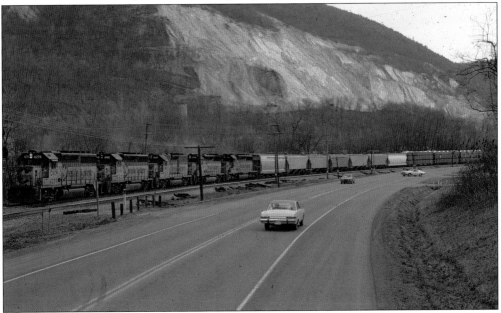

Extra No. 4279 is headed west at Mount Savage Junction and is assisted by Nos. 4142, 3847, 4374, and 7606, totaling a lot of power. A stop at Hyndman may not be necessary. All things considered, this train was really moving, and to get this advantageous photograph location, I had to climb on top of my truck. At one time, an interlocking tower, similar to the one at Viaduct Junction, with the telegraph call letter J, was located behind the last diesel unit.

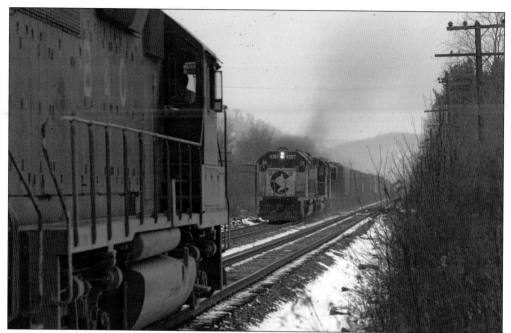

On January 11, 1980, I found Extra No. 3760 east meeting Extra No. 4357 west at speed. Railfan photographers live for photographic opportunities like this. Though the lighting was not studio quality, the undeniable beauty of the scene and the cold day were captured at the right moment.

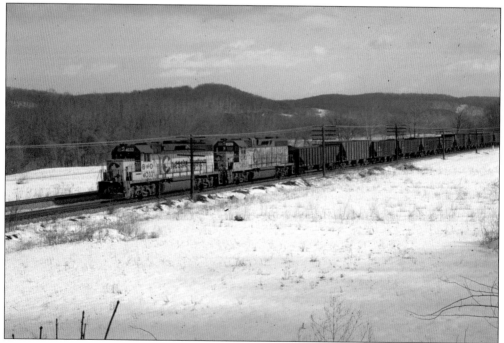

On January 24, 1987, just north of the Maryland-Pennsylvania state line, we have Extra No. 4033 west, running on track No. 2, against the normal flow of traffic. This is an ore train from Baltimore, Maryland. A few miles ahead, "helpers" will be added to assist the train over the hill.

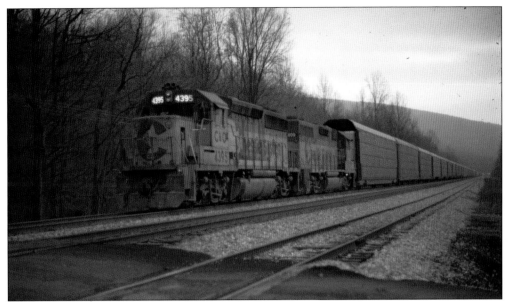

We are just west of Cooks Mills, Pennsylvania, at a location known to train crews as "Slip Rock," on December 27, 1986. The track in the foreground is the running track from the helper station at Hyndman, Pennsylvania, just to the west. This is Extra No. 4395 west with an auto train out of Jessup, Maryland. The train has stopped just short of the grade crossing so as to not tie up the road for vehicle traffic. The helpers are on their way from our left, will continue on the near track to a crossover in the distance, tie on the rear, and send the train on its way.

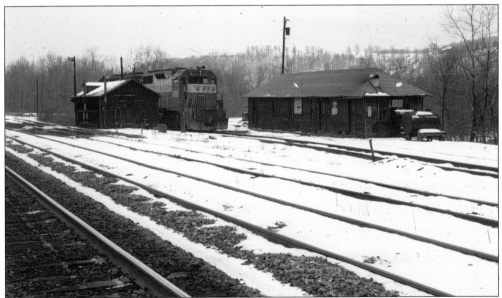

This is the helper station at Hyndman on November 1, 1980. We see, from left to right, the sand house, a set of helpers, and the train crew's quarters. Toward the end of steam's heyday, no fewer than eight S-1 and S-1a 2-10-2 "Big Sixes" were stationed here. They were replaced by diesel power in 1957. The two tracks, nearly covered by snow, are where the steam locomotives would stay until their next assignment. They usually ran in pairs, as do the diesels. With only one set of helpers in the yard, that means that the other two sets are somewhere on the hill.

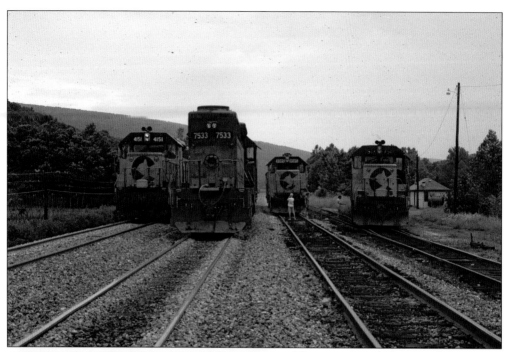

This was a posed photograph by the helper train crew. Extra No. 4151 west was the through train and No. 7533 was to be the helper. The engineer told me he would stop the No. 7533 so that I could get a photograph of four locomotives side-by-side. The other two helpers would wait their turn at the hill. The date is July 19, 1986, and by this time, Chessie had re-sided the crew quarters to the right.

There is a lot going on in this photograph, which was taken from the engineer's seat of a helper. The tank car in the upper right of the photograph is part of westbound train No. 397 that is going away from us. The helpers, in the mirror, in the lower part of the photograph, are on the rear of the train, and are coming toward us. This fortunate photograph was taken on April 12, 1986.

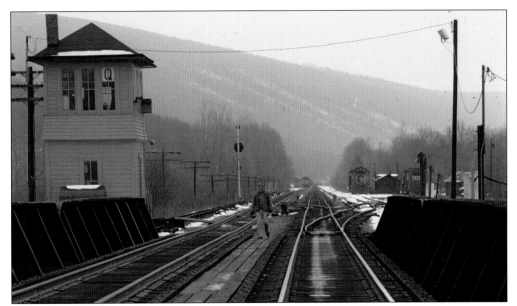

This is an overall view of the helper station at Hyndman, Pennsylvania, on January 11, 1980, looking east. At this time, the appearance has changed little since the days of steam. Q Tower is to the left and controls the interlocking here and access to the yards at the right. In the background is a westbound train, and two sets of helpers are at the right. The bridge in the foreground is over Wills Creek. Today, the only thing left is the double-track main line. The tower, yards, and supporting structures are gone.

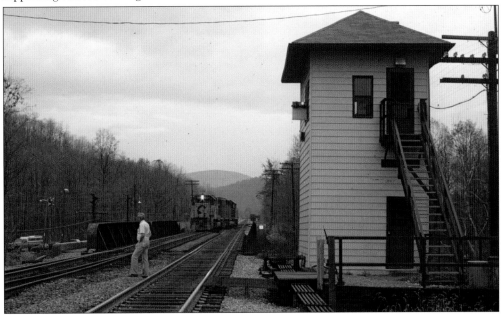

In this view, we look west at Q Tower on November 10, 1984. By this time, Chessie had modernized the tower with new siding and windows. The tower was now 88 years old, and its days were numbered. The tower operator was coming over to talk to the helper crew that was coming into the helper pocket behind us to the left. The helpers came down the hill on track No. 1 against the normal flow of traffic.

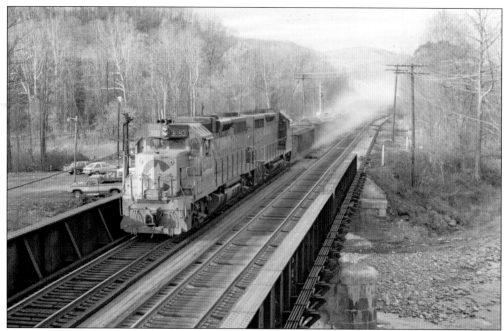

Sand Patch is a long and steep grade. Here, on November 9, 1985, we see Extra No. 3892 east coming off the hill with the brake smoke flying. From Hyndman east, the grade is relatively flat and the train will be able to coast into Cumberland, Maryland, some 15 miles away. That will help to cool off those brake shoes and wheels. Brake shoe smoke is a smell that one will never forget.

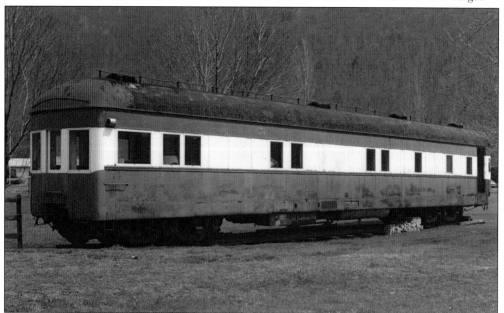

In May 1990, I photographed the sole surviving passenger car from the 1940 *Columbian*, one of the early modernized train sets on the B&O. This was a café/observation car that also had a bar and stewardess room. The overall appearance of this car is original, but the paint is for preservation. Time eventually caught up with the No. 3303, and in the fall of 2014, she was finally cut up for scrap. For years, she was owned by Tom Cunningham, the mayor of Hyndman.

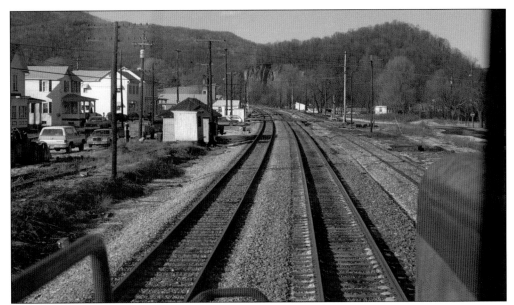

This is a fireman's view from the helper as we ascended the grade west through town. Taken on December 28, 1985, this photograph shows us approaching the Market Street grade crossing. The Pennsylvania Railroad interchanged with the B&O here and entered town just to the left of the stop sign at the extreme right center of the photograph. Along with some interchange traffic, there was a quarry here that, during steam days, provided limestone for the steel industry and the railroad for ballast for the right-of-way.

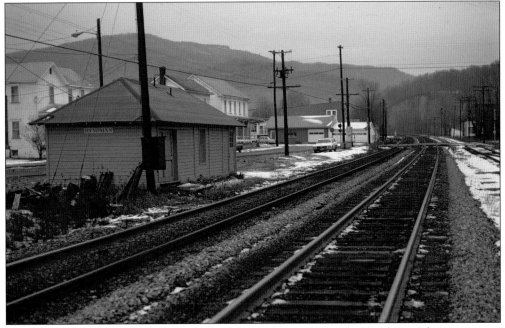

Here, on January 11, 1980, is a photograph of the section tool house in Hyndman. These structures could be found all over the system. Their purpose was to provide a shelter for tool storage for the track maintenance forces as opposed to having to transport the equipment from long distances away. In some cases, small motorcars could be stored inside.

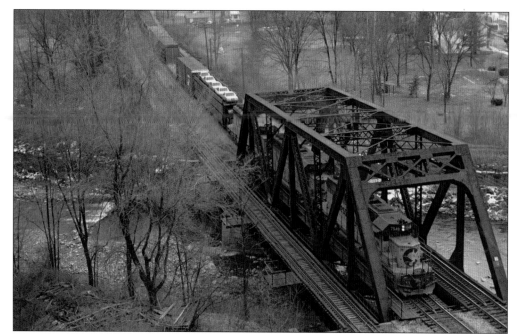

This photograph of No. 397 was taken on February 22, 1987, from the cliff overlooking the west end of town. The bridge spans Wills Creek. No. 397 was an auto parts train from Baltimore. Experience had taught me that the best time of the year to take photographs was in the winter when the trees were bare.

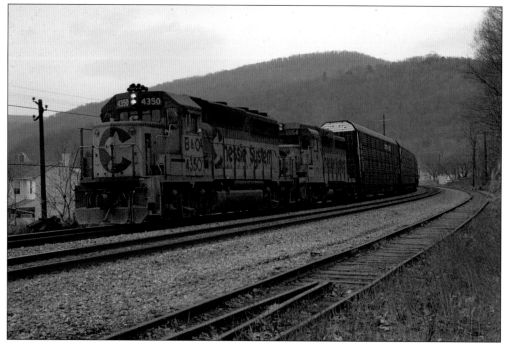

After climbing down off the cliff, I caught Extra No. 4350 east about to cross over the Wills Creek Bridge to the left. This photograph tells the real truth about the third track up the hill at this time; it was overgrown with weeds; it had essentially been abandoned and would soon be taken up.

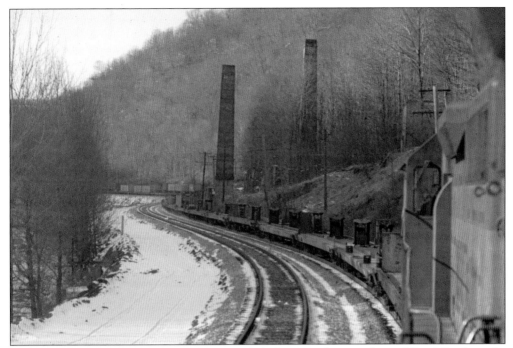

I took advantage of many opportunities to ride helpers up the east slope of Sand Patch grade. Here, on December 28, 1985, we were on the rear of a Chicago-bound *Trailer Jet* passing the long forsaken brickworks at Matswell.

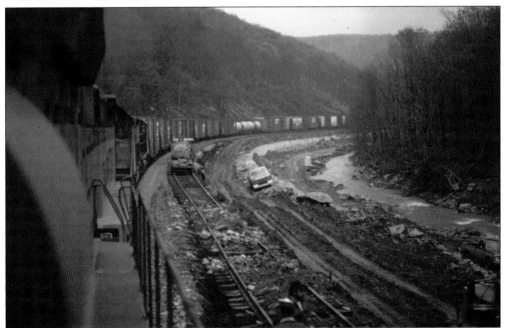

Here, you can see that track No. 2 is out of service. The retaining wall down in the creek was built by the railroad decades earlier. Wills Creek looks quite docile here but had no trouble rising well in excess of 30 feet to wash out the main line. The author has no doubt this will happen again. When the water reached Hyndman in a 1985 flood, it was a wall in excess of 10 feet high.

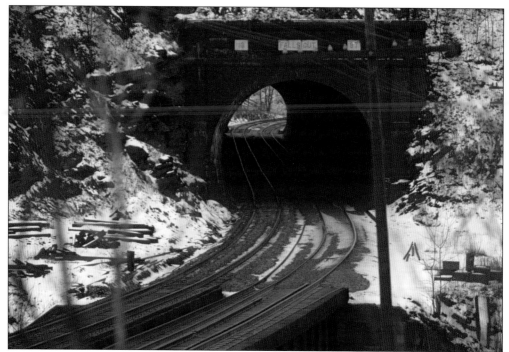

This is the east portal of Falls Cut tunnel, built in 1897, and photographed on January 11, 1980. The two bridges, seen at each end of the tunnel, are over Wills Creek. The original main line went from the left foreground on this side of the bridge and around the hill to the right, following Wills Creek. While this S curve may seem sharp, it was a blessing when the tunnel was built.

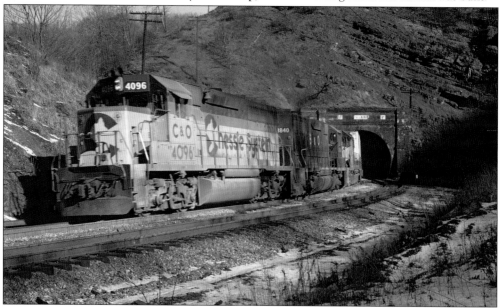

This is the west portal of Falls Cut tunnel, photographed on January 12, 1980. No. 4096 is bringing the *Chicago Trailer Jet* through the tunnel and over Wills Creek Bridge. The day before it had been overcast and drizzling, and today it was clear and sunny. Both weather conditions have their photographic advantages.

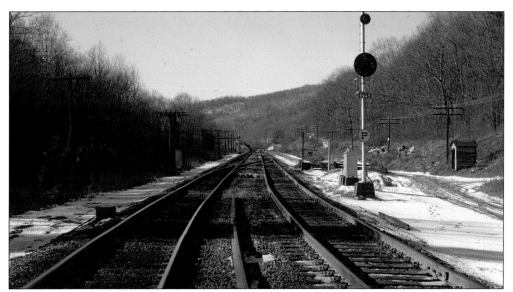

It is January 12, 1980, and we are now at Foley, Pennsylvania, looking west. FO Tower sat behind and to the right of the color position light (CPL) block signal. It was similar in appearance to Q Tower at Hyndman. FO Tower controlled the switches for the third track up the hill. Three tracks were needed in order to keep traffic fluid on the hill. The last thing the railroad needed was to have a slow-moving freight ascending the grade and have a passenger train behind it with nowhere to go. Foley was remote, hence the outhouse. When the tower was removed due to dieselization, the outhouse remained for use by track crews.

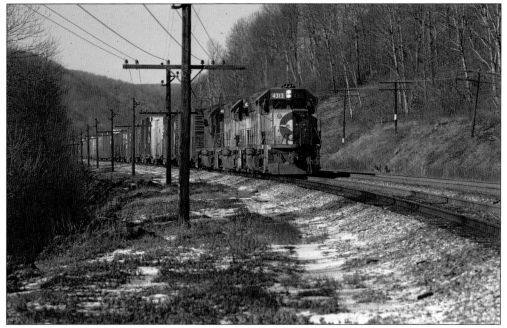

Extra No. 4313 leads eastbound freight No. 397 through Philson, Pennsylvania, on January 12, 1980. This train was following a set of helpers down from Sand Patch. These are EMD (Electro Motive Division of GM) GP-40s and were the most numerous locomotives in the fleet with over 400 units. Rated at 3,000 horsepower, these units could really move the freight.

This is Northampton, which was where a water tank was located on the third track for emergency water for locomotives. The abandoned third track right-of-way can be seen through the middle of the photograph, which was taken from a helper on May 31, 1986. The need for three tracks and the water tank was eliminated with the advent of dieselization.

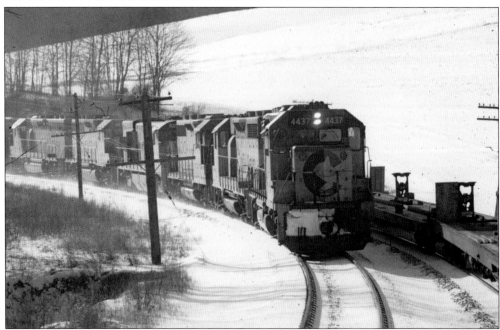

Taken from a helper on December 28, 1985, this photograph shows the *Chicago Trailer Jet* west at Mance, Pennsylvania. No. 4437 is on the head end of a grain extra, eastbound for the Locust Point Marine Terminal in Baltimore. If you take a look back at previous photographs of our train back in Hyndman, you will see the effects of higher elevation in the winter wonderland seen here.

This is Manila, Pennsylvania, on October 7, 1989. GR Tower sat to the right of the relay box in the center of the picture. The tower was removed in the mid-1950s, and these switches were controlled from SA Tower in Sand Patch. The propane tank is for the switch heaters, which were under the plates beside the rail. This is a very important location for traffic on the hill, and the railroad cannot afford for the switches to freeze up in the dead of winter.

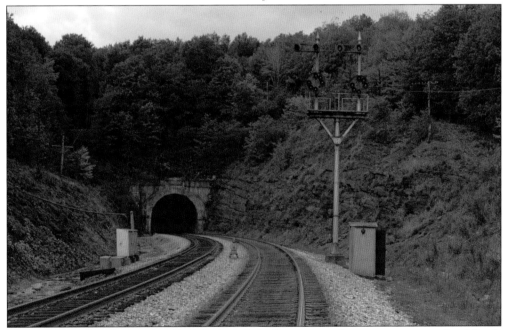

Turning around, and a couple of hundred yards farther west, is the east entrance to Sand Patch tunnel. This is the second tunnel at this location, and it was completed in 1913, with a length of 4,475 feet. Due to its length, it was necessary for two vent shafts to be dropped 234 feet below the mountain summit.

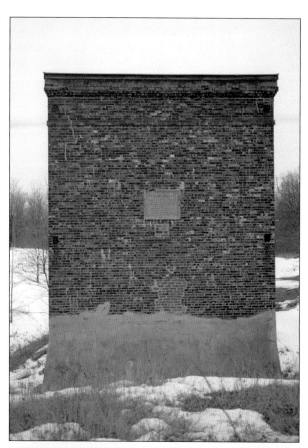

Photographed on February 22, 1987, this is one of the two vent shafts for Sand Patch tunnel. Quite a bit of work went into the two shafts that were essential in the days of steam. Though steam has been gone since 1957, these vents still serve their original purpose today. The last thing you want to do is have a train stall in the tunnel with a locomotive in there.

A lot of people were responsible for the work on the tunnel, but the ones that were immortalized in concrete for their work on the finished 1919 shaft were the following: "E. Stimson. / Gen'l. Supt. M of W & S. [Maintenance-of-Way & Service] / C.W. Andrews. / Asst. Gen'l. Supt. M of W & S / M.M. Corrigan. / Insp'r of tunnels. / Thos. Courtney. / Gen'l. Foreman." Today, this type of recognition for work accomplished is a thing of the past.

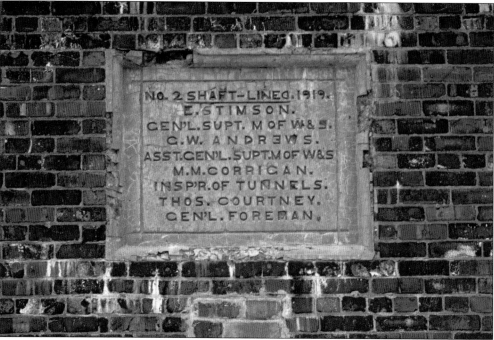

Two

THE MAIN LINE
WEST SLOPE

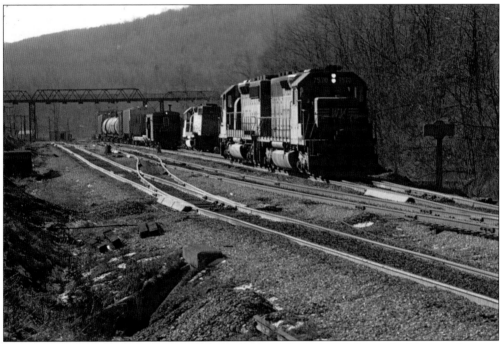

With the Chesapeake Bay watershed behind us, we now look toward the gradual drop in elevation to Pittsburgh and the Ohio River. Whenever possible, early railroads chose water-level routes for their gradual grades. The downside was the presence of floodwaters. The B&O's destinations were the rich industrial center in Pittsburgh and the coalfields in the areas it traveled through. This was also an asset in the steel industry. The west slope helper base was at Connellsville, Pennsylvania, some 50 miles away from Sand Patch. Depending on the size of the freight train and its location on the hill, helpers on the west slope could be added at Garrett, Rockwood, or Confluence to assist a high-tonnage train. From Connellsville to Grant Street in downtown Pittsburgh, the grade was relatively easy. At Glenwood, in Pittsburgh, the B&O built one of its three main locomotive shops that served the railroad well into the Chessie era. We are at Sand Patch looking west on January 12, 1980. Train No. 396 travels away from the helpers that have just cut off. The other locomotive, No. 4096, broke down with a mechanical failure and is waiting to be picked up and returned to Cumberland, Maryland, for repairs in the shop. Mountain railroading can quickly take its toll on a locomotive, causing all kinds of failures that do not happen on the flats.

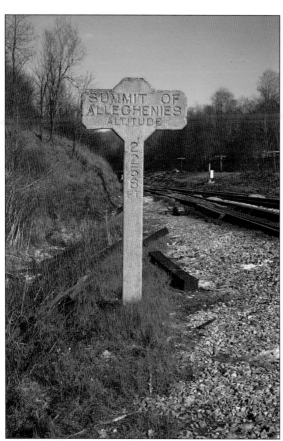

Here is an elevation marker denoting that we are at 2,258 feet above sea level. The B&O was the first railroad over the Allegheny Mountains at the highest elevation.

SA Tower is to the right on the bank. This is where eastbound and westbound freights and helpers do their dance to stay out of each other's way as they try to keep traffic fluid. The concrete elevation marker can be seen at the left. This has always been a busy location and a great spot for railfans to gather for photographs.

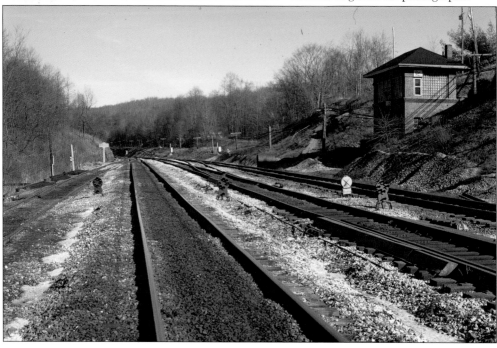

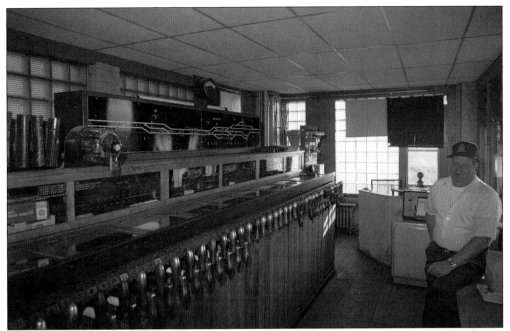

By the time I arrived on March 8, 1987, at SA Tower, the second trick operator was on duty. In the 25 years that I spent photographing the B&O, I never once was told to leave or asked what I was doing. The railroad was made up of hospitable employees who were always willing to help. This view shows what the Taylor Electric Plant looks like. The tracks are to our right.

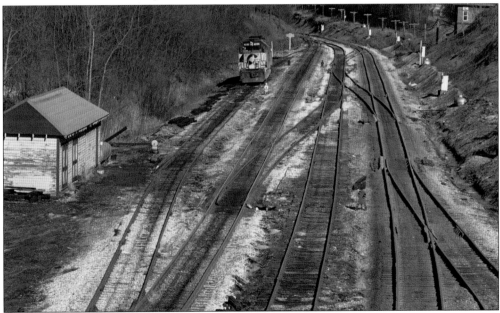

Taken from Deal Road, this photograph shows Sand Patch and the interlocking tower on January 12, 1980. We are looking east at the section tool house on the left; road power waiting to go east in tow to the Cumberland, Maryland, shops; and the SA Tower. Sand Patch tunnel is just out of sight around the curve to the left in the background. From left to right, the second and fourth tracks are the main lines. The other two are pockets for the helpers or disabled power.

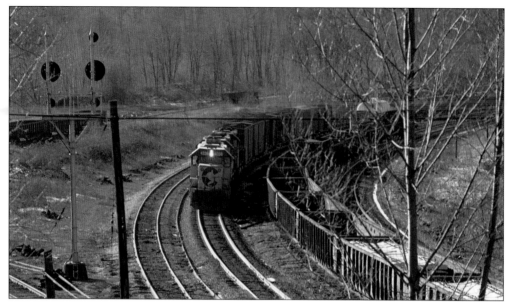

It is January 12, 1980, and Extra No. 4338 east is entering the Sand Patch interlocking. Her work, climbing the west slope of Sand Patch from Connellsville, Pennsylvania, is over. Now, it is time for some brakes and a long descent into Cumberland. In the background to the left, behind the block signal, is the interchange track with the Western Maryland Railway. In the lower-right corner, we can see concrete ties inside the gondola cars. These are an experiment that will prove successful in the future.

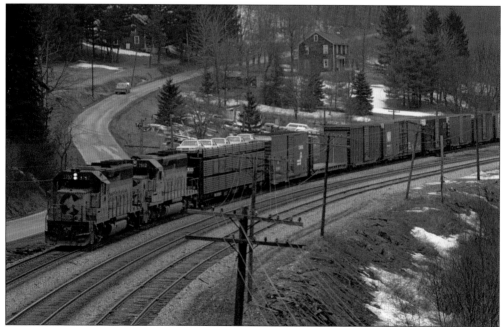

In order to get this elevated picture at Keystone, Pennsylvania, on February 22, 1987, of train No. 397, I was compelled to climb atop a block signal. No. 3787 is approaching Glade City Road to our left. At this time, there were still three tracks on the west slope of Sand Patch. The near track was for slow-moving freights.

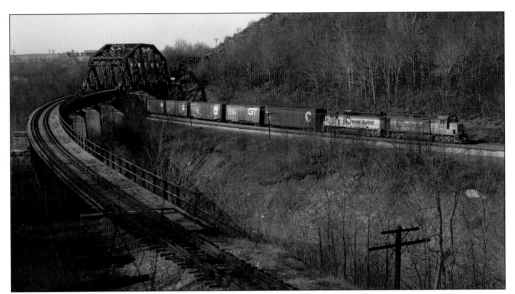

Extra No. 4114 east is pictured with No. 4379 assisting. The western slope of Sand Patch is not nearly as steep as the eastern side. Thus, trains haul more tonnage per unit than their westbound counterparts. Though they also have helpers, they, too, are at a crawl, and I could hear this train when it got to Meyersdale, Pennsylvania, some three miles away. It took no fewer than 10 minutes to cover the distance. In the foreground is the Western Maryland's main line to Connellsville, Pennsylvania. The bridge and piers were built for a double-track main line that never saw more than the single track shown here.

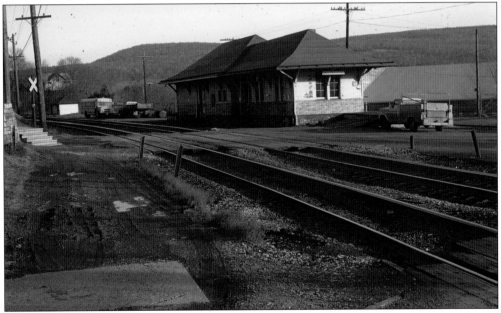

On January 12, 1980, I found the Meyersdale passenger station here on Main Street. Though it had been almost a decade since the last passenger train had stopped here, because of the maintenance-of-way forces having need for its interior space, it was none the worse for wear. We are looking east, and at one time, there was a westbound waiting shed that sat across the tracks to our left just beyond the stairs. A section tool house is in the background.

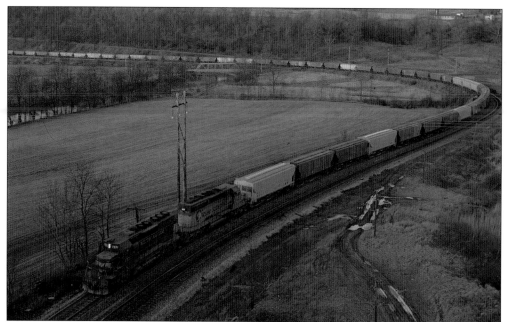

This panoramic view was taken from the Western Maryland's Salisbury Viaduct in the late afternoon of January 12, 1980. Extra No. 7571 east is bound for Locust Point yards in Baltimore. This was a grain train for export to Europe. The Casselman River is at the left. We are looking west toward Garrett, Pennsylvania. Today, US Route 219 cuts right through the scene.

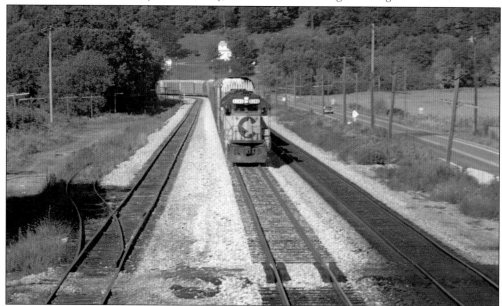

On this afternoon of September 27, 1988, I caught an eastbound auto train coming through Yoder, Pennsylvania, and its destination was Jessup, Maryland. In the days of steam, this was the location of a huge reinforced-concrete, three-silo coal tower and water station. The coal tower straddled the left and center tracks, and serviced all three tracks. There were two 100,000-gallon wooden water tanks that were to the right of the tracks. The siding is where coal cars were set out to supply the coal tower with fuel for the locomotives.

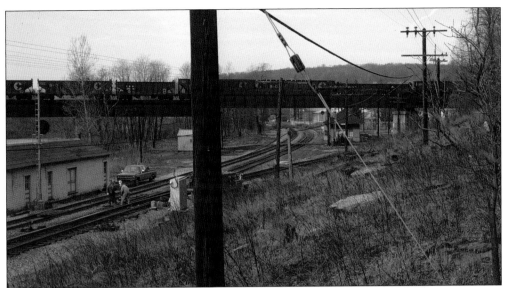

Welcome to Rockwood, Pennsylvania. In this overview on February 24, 1984, there is quite a bit going on. On the left is a section tool house that is being used by the track crew members, who are in the process of repairing the switch on track No. 1. The bridge overhead is the connection between the WM to the left and the S&C (Somerset & Cambria) subdivision to the right, which goes to Johnstown, Pennsylvania. The passenger station is on the other side of the bridge and is also used by the maintenance forces. The switch in the foreground leads to the right and connects with the overhead track about a mile away.

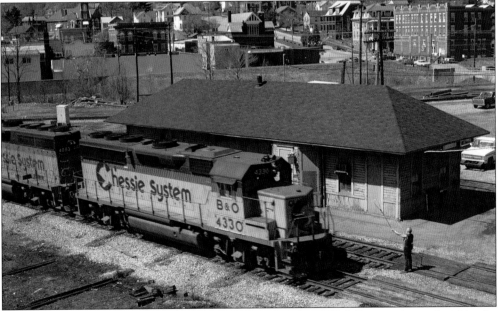

This scene was played out dozens of times a day for decades. RW Office was located within the passenger station. Here, we see the operator about to hand up orders to the train crew of No. 396 as they pass by. You will notice that he has forks in both hands; one is for the engineer and fireman, and the other is for the conductor in the caboose. This photograph was taken on April 19, 1986, from the overhead bridge.

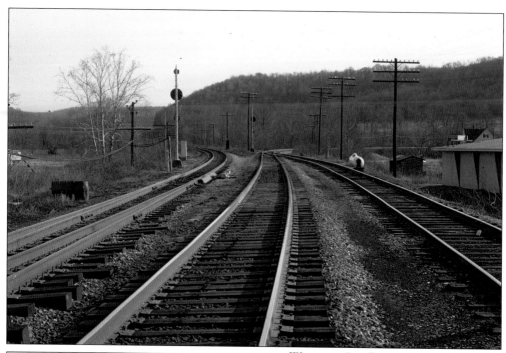

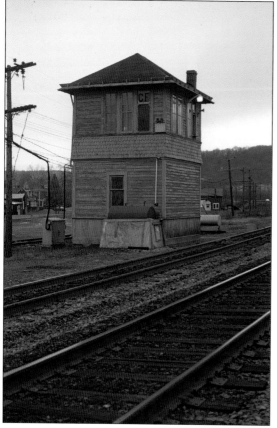

We are at Confluence, Pennsylvania, looking east, with the original high line to our left and the newer low line to our right. The high line was always a steep "fly in the ointment" for the railroad's eastbound traffic, so much so, that the railroad opted to build a longer but more gradually graded line along the river years later. Both lines have always been single tracked, and traffic has always been bidirectional. Preferably, the high line carries westbound traffic.

Pictured on January 13, 1980, is CF Tower. The tower controlled the interlocking for the high and low lines, as well as C&O Junction to the west. This is the tower's "as built" appearance. Chessie placed new siding on it a few years later, but it was destroyed on May 6, 1987, at 4:10 a.m. in a train wreck that killed the tower operator.

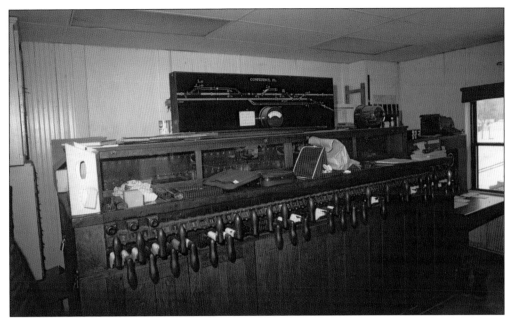

Just three months before the tower was scrapped, I had the privilege to see the inside of CF Tower on January 31, 1987. It had been modernized on the outside, but the inside was still the same. This is the original Taylor Electric Plant, which was installed when the tower was built in November 1903. Electricity was in its infancy at that time, but the Taylor Electric Plant was still working 84 years later, with no need of replacement.

On December 7, 1985, I found Extra No. 4255 east passing through C&O Junction, just west of Confluence, Pennsylvania. Of particular interest was the WM caboose behind the third diesel unit. Normally, a caboose would be carried on the rear of a train. Most likely, what we see here is a car that, due to the times, was going to be scrapped, as most cabooses were at that time. A FRED (flashing rear-end device) would eventually replace them.

Extra No. 4352 is westbound at Casparis, just east of the Connellsville yards on October 26, 1981. The Youghiogheny River is to the right. This train could be terminating in Connellsville or it could be simply changing crews, as this is also a crew change point. Either way, it has been a long trip over Sand Patch!

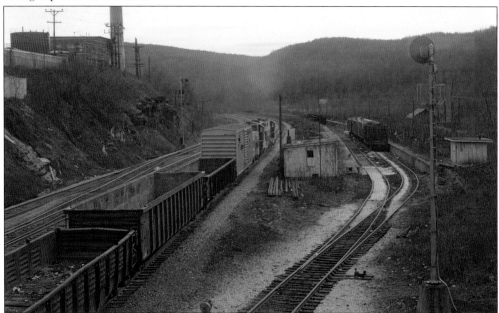

We are at Green Junction in Connellsville on January 13, 1980. This photograph was taken from WH Tower, and we are looking at the livestock pen to our right, which is where livestock was unloaded, watered, and rested before being reloaded and sent east for slaughter. The train in the center is made up of a pair of 1,750-horsepower GP-9s that are working the westbound hump, switching cars.

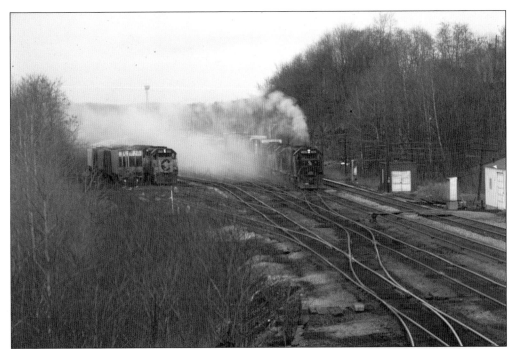

Where's the steam engine? There isn't one. This is a common sight when a diesel with a lot of hours on the engine has been idling for a long time and suddenly is required to work. The smoke dissipates quickly and is the result of incomplete fuel burning. On January 13, 1980, train No. 396, headed by No. 4076, is leaving the Connellsville yards. Shortly thereafter, Extra No. 3512 east (on the left) will follow.

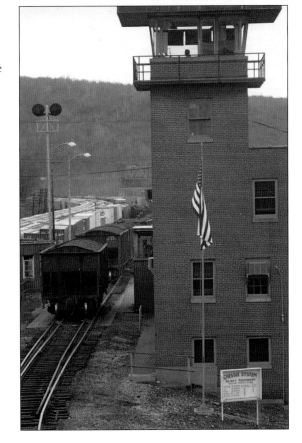

This is the hump tower and track scales in Connellsville on January 13, 1980, as seen from the employee overhead catwalk. As new as this appears, this was built in the mid-1950s. The yard locomotives are pushing the train over the top.

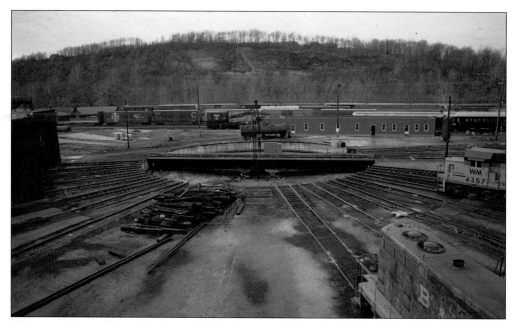

The turntable at Connellsville is 115 feet long and was capable of turning the largest steam locomotives on the B&O. The five-stall roundhouse is to the left, seen here on January 13, 1980. Most locomotives after they were serviced remained on the outside radial tracks. This was an unusual day, in that there were very few locomotives present. On the other side of the turntable were a 150-ton crane, a 10,000-gallon waste oil tank, and the crew quarters.

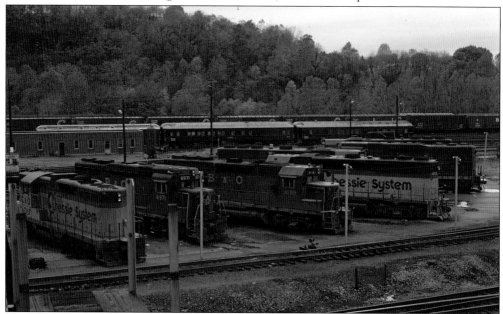

Now this was more like it. Power is everywhere in this photograph taken on October 26, 1981. All seven tracks are occupied with road and helper power for moves east or west. In this view, we get a better look at the blue work train that was assigned here to Connellsville. At one time, these cars were Pullman passenger cars that saw revenue service well into the mid- to late 1950s. When passenger service started to decline, they were transferred into maintenance-of-way service.

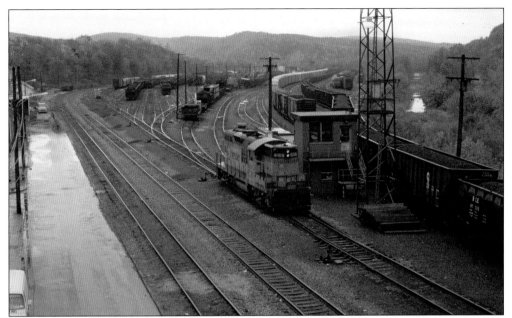

No. 6469 is working as a trimmer in the west end of the yards at RN yard office on October 26, 1981. A trimmer made sure all the cars were coupled up on each track. Sometimes a car would receive too much braking at the retarders and would coast short of the new train. When this happened, the trimmer would come in and make the connection. Water Street is below, and I am standing on the old PRR Bridge over the yards.

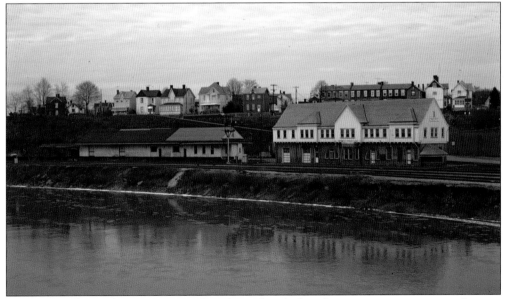

This image shows the importance that the railroad placed on its passenger service here at Connellsville. Originally built in 1897, this station was first remodeled in 1905 and then again in 1937. Seen here on January 13, 1980, in its 83rd year, its days were numbered. The passenger station was torn down and replaced with an AM-shed (Amtrak shelter). Someone with a great deal of pull must have been infuriated by this downsizing, because a new cinderblock-and-stone station was built to serve Amtrak's *Capitol Limited* passengers who pass this way now.

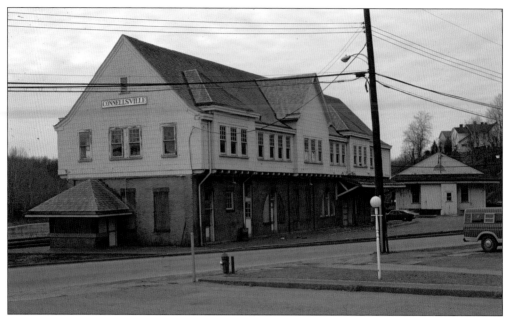

This is the Water Street side of the station. The newsstand on the end was a late addition (sometime after 1937) and is quite focal in this photograph taken on January 13, 1980. Note the cobblestone platform and driveway. Extravagant in its day, like so many ornate architectural designs, it is long gone today. The freight house in the background was on borrowed time as well, as it had not seen service in years. Both structures were extremely busy for decades.

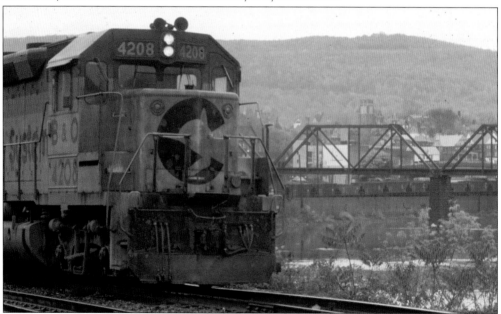

Extra No. 4208 west, seen here on October 26, 1981, has a long string of empty hopper cars returning to the mines. In the background, we can see the old PRR railroad bridge over the Youghiogheny River. The PRR station was on the other side of the river to the right. Years earlier, the railroad had abandoned this line. The bridge made a great platform from which to take photographs that could be had no other way.

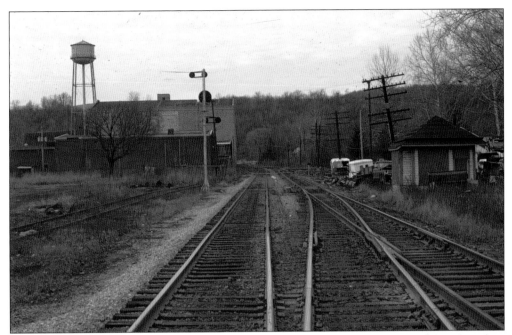

We are at Broad Ford, Pennsylvania, on January 13, 1980, looking west. On the left is the siding that served A. Overholt & Co. BF Tower is on the right. By this time, it was out of service and boarded up awaiting demolition. In the background was the switch for the Mount Pleasant & Broad Ford Branch that ran 9.7 miles to Mount Pleasant, Pennsylvania.

This is the Versailles station and agent's office on October 10, 1986. This was the eastern end of commuter rail service on the B&O, 18 miles out of Pittsburgh. At one time, commuter trains ran out to Connellsville. A joint effort by Chessie and PAT (Port Authority Transit) saw that this office got new siding. This was a train order station at the east end of the interchange track for trackage rights over the P&LE.

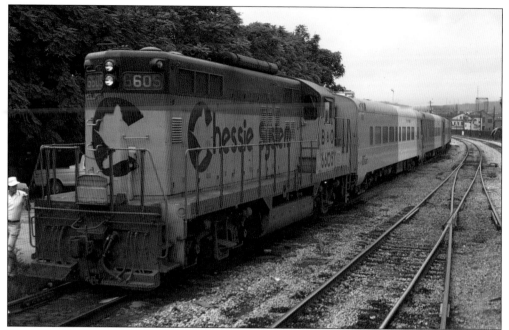

No. 6605 is the head-end power for this PAT commuter train at McKeesport, Pennsylvania. This is a steam generator–equipped GP-9 designed for passenger service. The date is September 1975, and though no heat is necessary at this time, it will not take too long before that steam heat will start to feel good. In addition to the colorful Chessie colors, PAT carried its own array of colors.

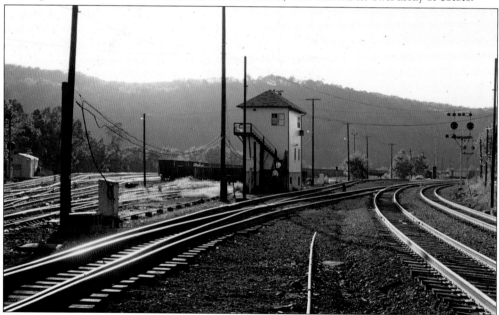

WJ Tower is located at the east end of the Glenwood yards at Glenwood Junction. It is seen here on October 11, 1986. The yards themselves are seen here on the left. The main line is composed of the two tracks on the right. We are looking west, with Grant Street station (the end of the main line) only five miles ahead. Most of the traffic that comes in and out of these yards is directly related to the steel mills in the area.

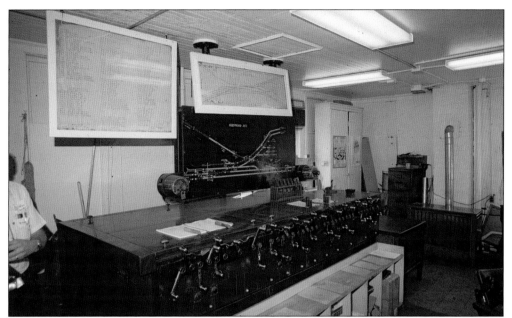

And this is the interior of WJ Tower, with its GRS (General Railway Signal) interlocking machine, the heart of it all. From here, trains are dispatched east to Connellsville over the main line; west to Washington, Pennsylvania, over the WP&B (Wheeling, Pittsburgh & Baltimore); and west over the P&W to New Castle, Pennsylvania. The black panel with the track diagram on it shows the main tracks through the interlocking.

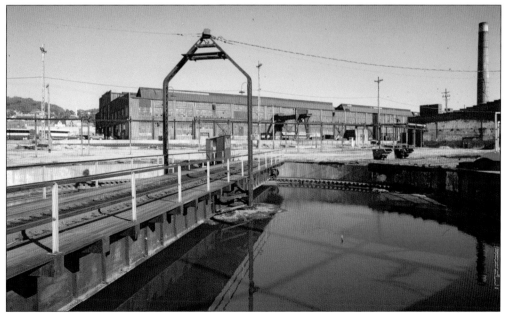

In the background are the Glenwood locomotive shops. An uncounted number of steam locomotives were completely rebuilt from one end to the other until 1952, when the shops were converted to the repair and overhaul of diesel locomotives only. Eventually, these shops were closed, and all overhaul work was performed in Cumberland. The large overhead crane brought parts from the outside stores inside for use as needed.

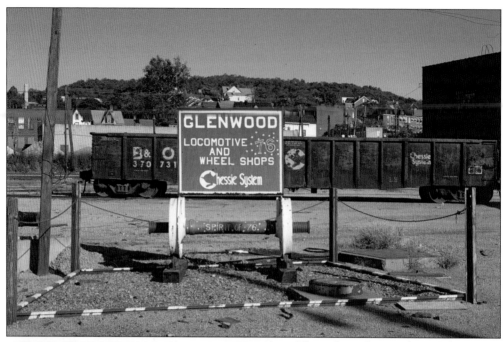

This is how the members of the Glenwood locomotive and wheel shop displayed their pride in their job and country on the country's 200th birthday. A fitting tribute to the people who labored hard to keep America's first railroad rolling. In 1976, the Chessie System was literally in its infancy. This photograph was taken on October 11, 1986.

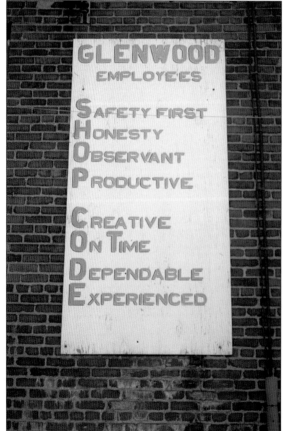

This plywood sign outside the shop employee entrance would be the motto of good railroad employees everywhere. Without these guidelines, no company can succeed. Safety-oriented signs and slogans like this one could be found all over the system. Many were tongue-in-cheek, and many had local themes. All had one goal in mind, which was coming to work, working, and returning home safely. A healthy employee is a company's best asset.

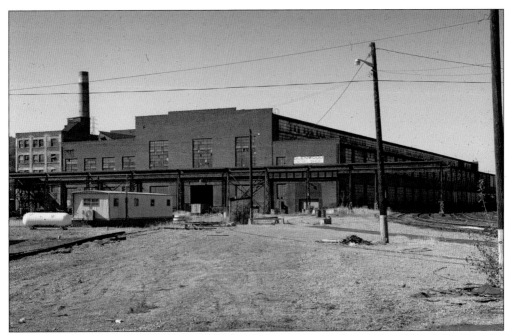

And this is the east end of the shops. Overhead cranes were on three sides of the shop. At right, we can see the tracks where railcars delivered material to the storerooms and where scrap material was loaded into gondola cars for outbound shipments. At left, we can see the power plant required to keep the shops going.

In the distance, we have the wheel shop for freight cars. Even at this time, Glenwood was the major shop for freight car wheel repair. Many a gondola car load from around the system departed and terminated here. The shop offices were located in the brick structure at the right.

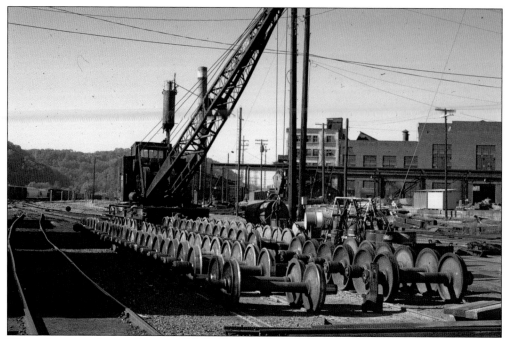

This rail-mounted crane has worked the shops for years, doing the same job day after day. The wheels on the right are the oldest. The wheels will be pressed off the axle. If the axle is good, a new wheel disc will be pressed on. The brightly rusted wheels are ready to be shipped out. The wheels on the left have recently been removed from their truck frames since the last rainfall. Literally, in a matter of hours, water will rust steel.

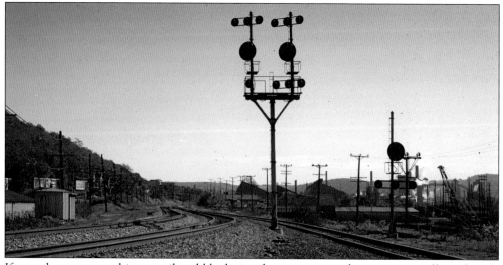

If ever there was an ultimate railroad block signal arrangement, this is it, especially with only three tracks! Every conceivable aspect is illustrated here. It would take a chapter alone to explain it all. We are at Laughlin Junction on October 11, 1986, three miles east of the passenger station at Grant Street. GN Tower sits behind where I took this photograph; the two tracks to the left are the start of the P&W and were used by freight trains going west. The single track to the right was used by passenger trains to downtown Pittsburgh. The location was named after the Jones & Laughlin (J&L) steel mill, which is seen in the background at the right.

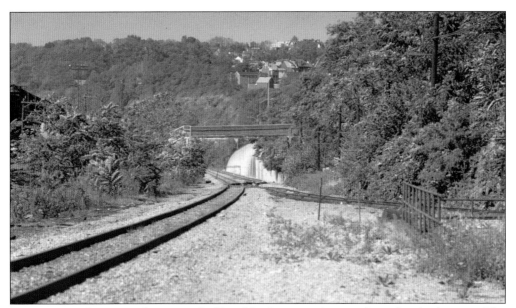

Turning around, we view the west end of Laughlin Junction. A wye is formed at this location. The single track to the left is the single track on the right of the previous photograph and was used by commuter trains to Versailles. The track swinging off to the right connects with the pair of tracks in the previous photograph. Passenger trains to and from Buffalo and Rochester used this track to access Grant Street station. The overhead pedestrian bridge is used by J&L employees to gain access to the steel mill to the left.

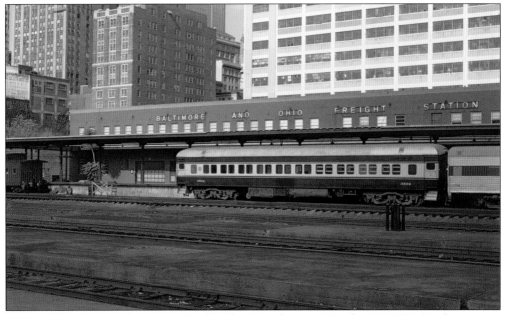

The freight station in downtown Pittsburgh is seen here on October 24, 1981. By this time, it saw little service. This was an early intermodal yard built by the B&O in November 1953. At the time of this photograph, its fate was unknown. The coach seen here is one of hundreds that were rebuilt by the B&O in its Mount Clare passenger car shops in Baltimore during the 1940s and 1950s.

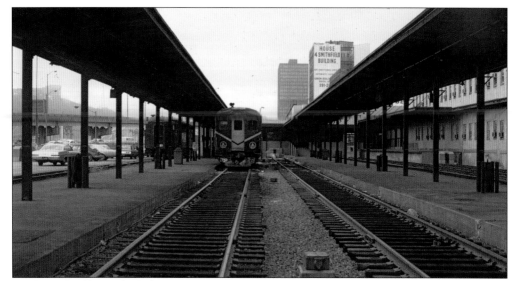

We have finally reached the end of the main line at Grant Street, 149.5 miles from Viaduct Junction in Cumberland, Maryland. The division offices are located in the building to our right. It is February 1974, and the B&O still had control of commuter trains to Versailles. Commuter service in both Pittsburgh and Washington, DC, was starting to ramp up, and the B&O's initial purchase of RDCs (rail diesel cars) was inadequate to handle the increase in traffic. The railroad bought some secondhand RDCs from railroads that no longer needed them. This particular unit was acquired from the Santa Fe, repainted, and put into service.

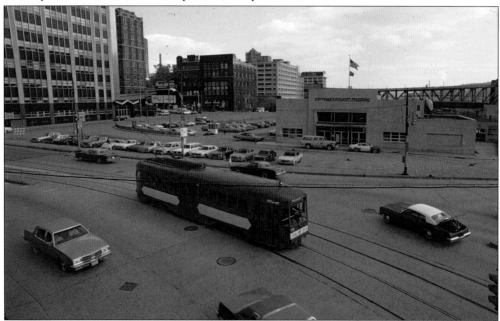

The station was located at Fort Pitt and Grant Streets, on Grant Street. Here, we see one of the Port Authority Transit's prewar Presidents' Conference Committee (PCC) streetcars that has recently been modernized with a newly designed front end. The car is in charter service. Imagine chartering a streetcar to ride where all the other streetcars operate. Streetcars no longer operate on the surface downtown.

Three

THE PITTSBURGH & WESTERN

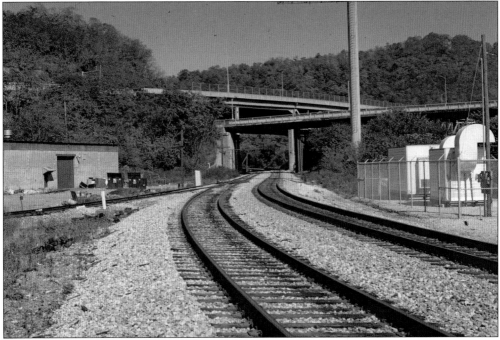

The Pittsburgh & Western left the main line at Laughlin Junction and was the original main line of the railroad prior to the trackage arrangements made with the Pittsburgh & Lake Erie Railroad. Once trackage rights were established with the P&LE, a high-speed water-level route was established, and the P&W became a secondary route west. At Eidenau, Pennsylvania, the P&W had a wye that connected the Buffalo Division of the railroad to the rest of the system. This was the main line to Buffalo and Rochester, New York. The majority of the P&W's freight traffic was over this section between New Castle and Butler, Pennsylvania. Before the demise of passenger traffic in 1955, the line from Laughlin Junction, Eidenau, and Butler was the B&O's passenger route to western New York State. The P&W starts at Laughlin Junction, seen here on October 11, 1986, looking west. The single track at the left is the leg of the wye leading to the Grant Street passenger station. The double-track main line on the right leads us up through Panther Hollow and eventually to the New Castle yards and the beginning of the Akron Division. Before the B&O acquired trackage rights over the P&LE, this was the main line west.

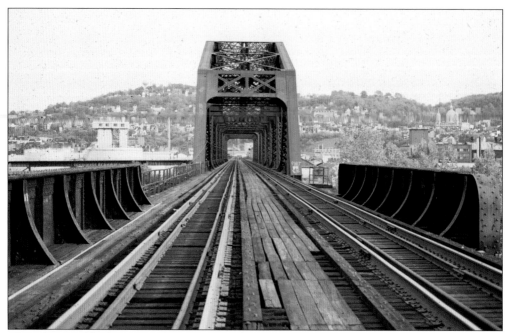

This substantial bridge spanned the Allegheny River at a location called Millvale. This photograph was taken on October 12, 1986. Below the through-truss bridge was Allegheny Yards, one of several yards the B&O had in the Pittsburgh area. At one time, this yard went down to where the original Three Rivers Stadium was located, serving many of the businesses in the downtown area.

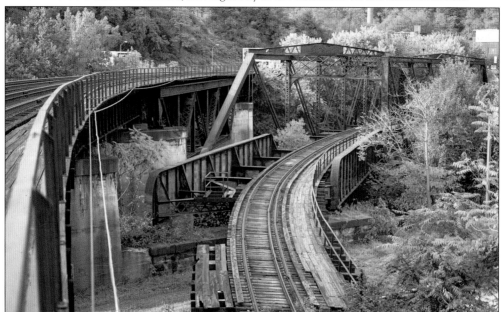

The bridge in the previous photograph is the "new" bridge. The earlier bridge, seen in this view below, used the same piers across the river as the new bridge. The replacement was the result of larger motive power and longer trains. In the days before Three Rivers Stadium, there were tracks below the bridge at ground level that led to dozens of Pittsburgh's biggest businesses and industries along the waterfront. The lower (original) bridge leads into Allegheny Yards.

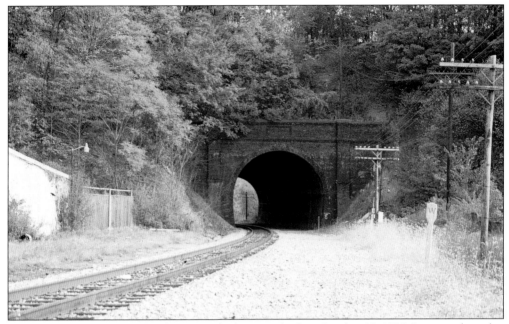

This is the west portal of Glenshaw tunnel, photographed on October 12, 1986. In steam days, this line was double tracked. The lack of traffic and the advent of trailer train and tri-level automobile cars saw the line downgraded to single track, mostly for clearances. This is a rather short tunnel at 199 feet long; it was built in 1900.

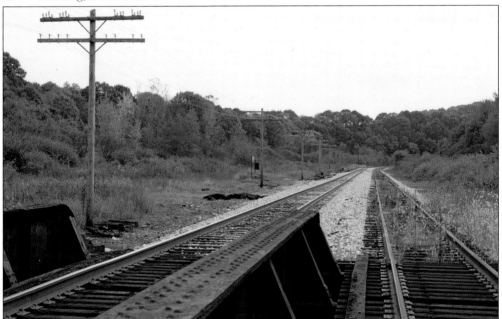

We are at Wildwood, Pennsylvania, and the Wildwood Mine, where a substantial collier was located to our right, along with WD Tower. Yard tracks for empties in and loads out were located to the left of the main line tracks. In steam days, there was even a penstock to take on water here. In the foreground is bridge No. 329, seen here on October 12, 1986. According to the mile marker to the left of the second telephone pole, we are 14 miles west of Laughlin Junction.

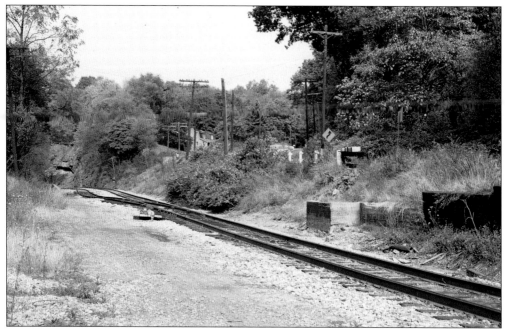

Bakerstown, Pennsylvania, seen here on October 12, 1986, is the top of the grade out of Laughlin Junction. The summit was controlled by RN Office, the concrete foundation of which can be seen at the right. Part of the original double track can be seen beyond the switch, which is now part of a passing siding. Station Hill Road is on the other side of the guardrail.

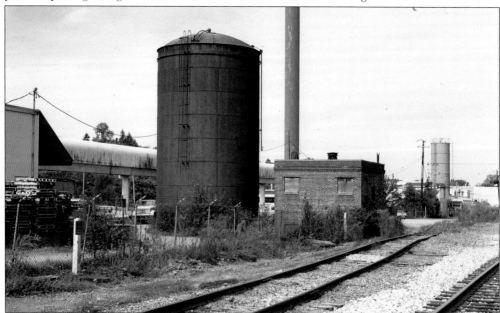

In the days of steam, locomotives needed water as much as coal, and the purer the water, the quicker the transfer from a liquid to a vapor. Water scale was a big problem for steam locomotives—so much so that boilers had to be washed out monthly to remove mineral deposits. This October 12, 1986, photograph shows the water treatment plant at Downieville, Pennsylvania; it now serves the industry behind it.

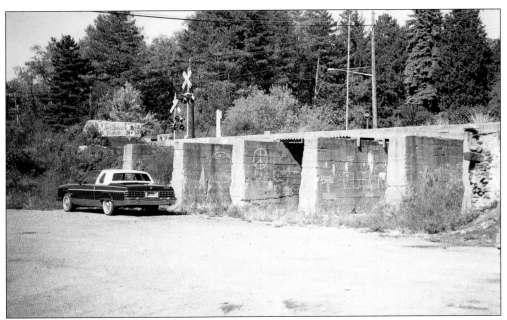

Well into the mid-1950s, the country depended on coal for use in homes, industry, and railroads. Many communities such as Downieville depended on this supply until the advent of heating oil and natural gas (cleaner alternatives). The different compartments would have been loaded with different grades of coal for different consumer purposes. A single track ran across the top of the piers, and the coal was dumped from the bottom of the cars by gravity.

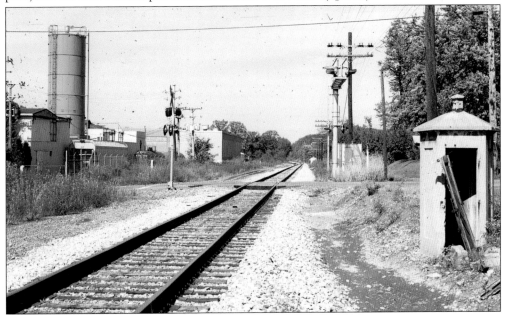

A very old ghost from the past is seen here at the Downieville Road grade crossing, and that is the concrete telephone booth at the right. No, this was not for public use, but rather for use by railroad personnel to communicate with tower operators as needed. With its close proximity to the water treatment plant, it was most likely used by the train crew to let the tower operators know of the train delays.

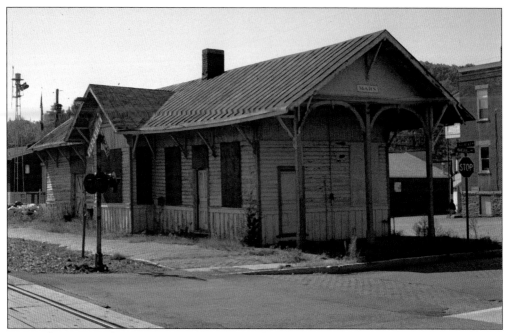

Pictured on September 27, 1988, is Mars, Pennsylvania. This station follows P&W rather than B&O architecture. Located at Marshal Way and Railroad Avenue, it hasn't had a passenger train in a long time. However, in 1992, returning from a trip to Chicago on the *Capitol Limited*, I awoke bright and early in my sleeper and was shocked to see Mars outside my window. A derailment on the P&LE caused our Amtrak train to be rerouted over the P&W.

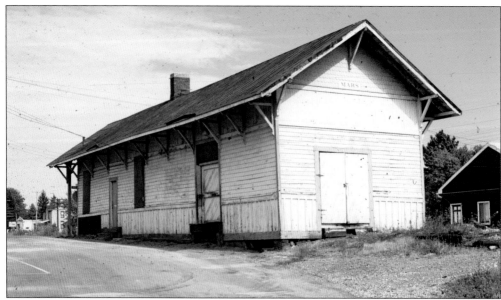

This is the Railroad Avenue side of the station on October 12, 1986. Boarded and locked up, the station has not seen any traffic—freight or passenger—pass through those doors for a long while. Maintenance-of-way forces used the building for years after it went out of revenue service. An HO scale model manufacturer made a craftsman kit of the station in the 1970s; unlike the prototype, it is hard to find these days.

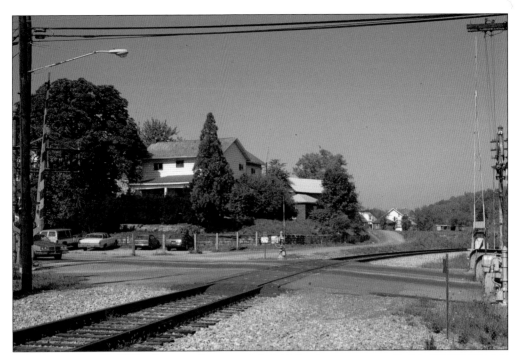

This September 27, 1988, photograph is at Evans City, Pennsylvania, at the Main Street grade crossing. The railroad used to have its passenger station on the other side of the road, and it literally straddled the stream out of view to the right.

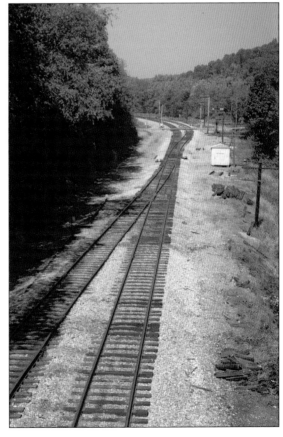

Eidenau is an important junction on the railroad, for it is where trains for Buffalo and Rochester, New York, leave the main line (to the right). There is a wye located here. The track to the left is the main line to New Castle. The silver relay box is located where the single-story MU Tower was located that controlled traffic here. Trains from Buffalo and Rochester could go west to New Castle or east to Pittsburgh.

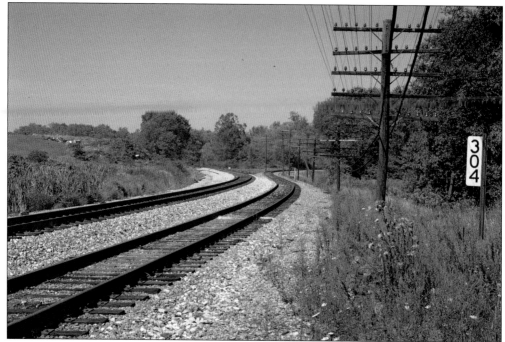

The mile marker indicates 304, meaning that it is 304 miles to Camden Station in Baltimore. Camden Station is ground zero. The track to the left goes west to New Castle, and the track to the right goes west to Buffalo and Rochester. Geographically, Buffalo and Rochester are north, but the railroad is configured from east to west.

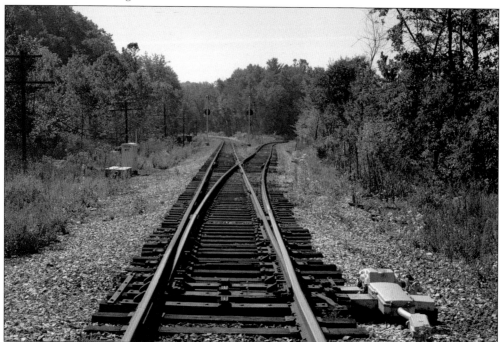

We are on the previous photograph's track from Buffalo. In this view, we are looking toward Pittsburgh. The track to New Castle diverges to the right.

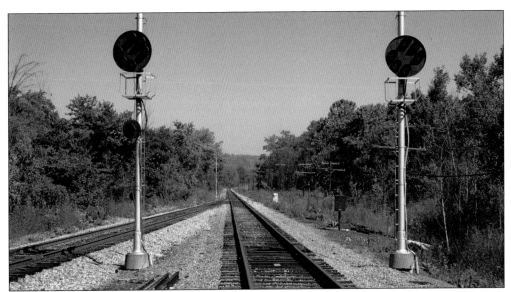

Fifteen miles ahead is Butler, Pennsylvania, and the beginning of the Buffalo Division. Although the left track sees more traffic, it is actually the right track that has the signal preference, as indicated by the high single target light at the top rather than below, as on the left signal (see photograph below). No fewer than half a dozen trains a day used this track at this time. At Downieville, we saw a substantial concrete telephone booth operated by the railroad. Here, at Eidenau, we see a far more modest application of a black telephone box to the right of the track, which is still in use today.

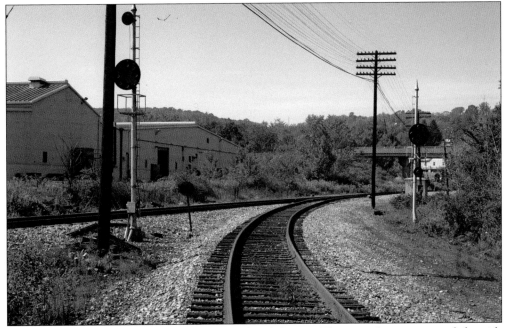

We are now reentering the P&W main line headed west. The main line is on our left, with the dominant block signal, and the line from Buffalo and Rochester is on our right. Wyes are important locations on the railroads but consume a great deal of real estate. The bridge in the background is Hartman Road.

Welcome to Harmony, Pennsylvania, on September 27, 1988. We are looking west at the Spring Street grade crossing. The former passenger station was located behind us on our left. The main line used to be double track. Note the close proximity of houses.

This is the New Castle Street grade crossing in Zelienople, Pennsylvania, on September 27, 1988. As we look west, several items become apparent, from left to right: the left siding is still used by the railroad, the eastbound track No. 2 has been paved over by the county, the main line is still active, and the passing siding did not need access from this end.

Track work is an ongoing aspect of the railroad. With the advent of ribbon rail in the early 1960s, track took on a new characteristic in the summer. With lengths of a quarter of a mile, it was prone to a great deal of expansion, called "sun kinks." These could easily derail a train. Seen here is a pile of "anti-creepers" beside the section tool house; anti-creepers were used to keep the rail from moving. There are four of these to each tie, which are hooked to the rail. If the rail starts to move, the anti-creeper locks against the tie, thus reducing rail movement.

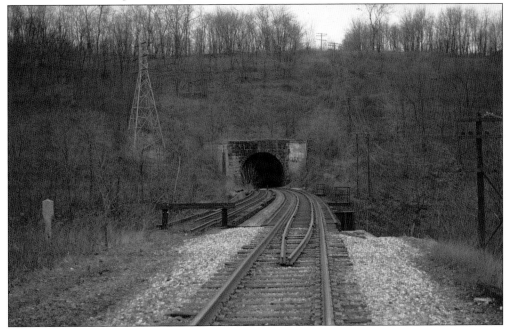

Ellwood tunnel was built in 1888. The east portal is seen here on February 20, 1984. The track that is in between the running tracks is referred to as guardrail by the railroads. The idea is to keep the wheels from allowing a car or locomotive from straying away from the track in the event of a derailment. This was especially important over bridges.

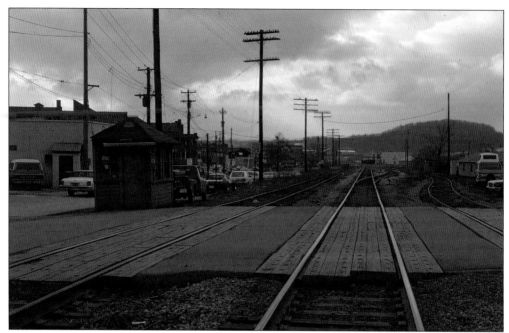

A rare find for a February 20, 1984, photograph was this watchman's shanty. We are at the Second Street grade crossing in Ellwood City, and there are no crossing gates to warn motorists—only the crossing watchman, whose job was to get out and flag traffic with the red stop sign leaning on the outside of the building. The watchman was alerted to an approaching train by a bell.

This area in Ellwood City, Pennsylvania, used to have a station. All that was left at the time of this 1984 photograph was the cobblestone platform, which can be seen to the right next to the nearest railroad telephone pole.

Four

THE SOMERSET
& CAMBRIA

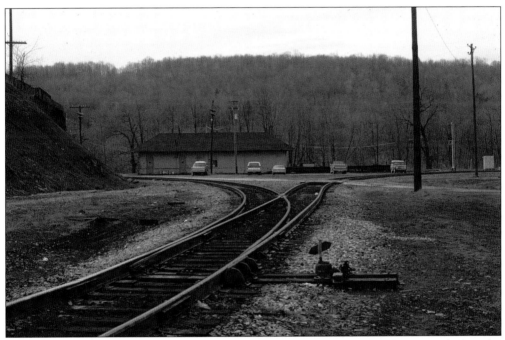

The Somerset & Cambria left the main line at Rockwood, Pennsylvania, and continued 45.1 miles north (railroad west) to Johnstown, Pennsylvania, where it interchanged with the PRR. The large steel mill operations in Johnstown provided the B&O with a small share of the traffic in town (the PRR saw to that). There has always a good bit of coal traffic that has kept the subdivision going, even to this day! Because of trackage rights worked out between the B&O and the Western Maryland Railway, the line saw regular WM trains going to the Somerset area to their respective mines. Eastbound B&O coal traffic and the trackage rights saw a bridge over the B&O main at Rockwood that served both railroads and gave the B&O a much easier eastbound grade to Garrett over the WM. These are the two legs of the wye. The left leg runs east to Garrett and Cumberland. The right leg runs west to Connellsville and points west. We are looking at the back side of the passenger station. This photograph, taken on February 24, 1984, shows how sharp the curve east actually was. In the days of steam, the huge articulated locomotives were challenged by their length to negotiate this curve, in addition to the grade east, hence the overhead bypass.

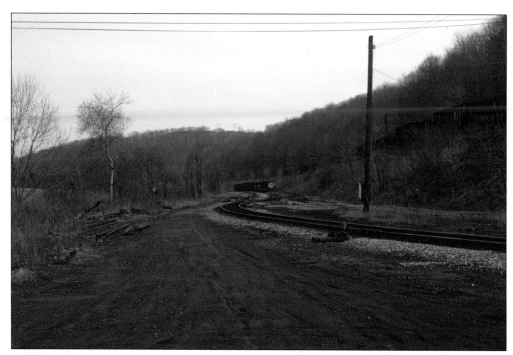

We are now looking toward Johnstown. This is all that is left of the yards at Rockwood on February 24, 1984. Five or six tracks were once located here, loaded with both empty (inbound) and loaded (outbound) coal cars. The eastbound bypass can be seen on the right side up on the bank.

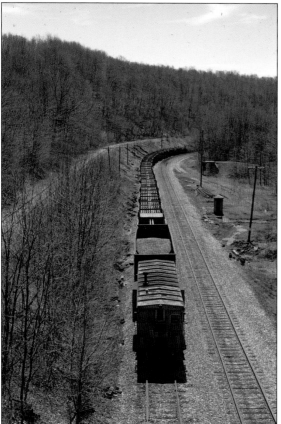

There is a lot going on here! On the left is the eastbound bypass. This was also used by the Western Maryland Railroad to gain access to their mines just west of Somerset via trackage rights. The train is a rail train, which transports new and used rail for the track crews. At the right is a concrete telephone booth for the railroad, and behind that is a coal-loading facility for trucks. Small coal operations used this simple method to load coal cars; they dumped right into the cars, as seen on April 19, 1986.

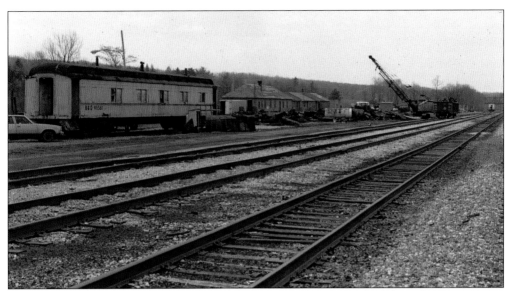

This is the east end of the Somerset yards, seen on April 27, 1991. At the left is a former passenger coach, now relegated to camp car service. To its right, in the background are the former car repair shop buildings. At one time, there were close to half-a-dozen tracks located where the scrap metal now resides. Somerset was just one of many car repair shops on the railroad because of its proximity to the many coal mines on this line. At this time, the scrap was not that of worn-out or damaged freight cars, but that of a railroad that was downsizing its facilities. The crane will load the gondola with scrap, which will eventually head to the steel mill.

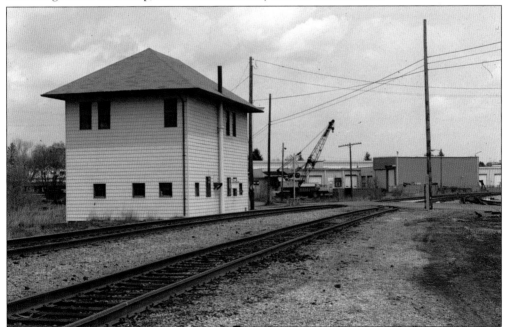

Welcome to SX Tower! This was a combination office (second floor), crew quarters (first floor), and tower (second floor); it was a bit unusual for the railroad. Seen here on April 27, 1991, in a westerly view, it is the only remaining railroad structure in town. Center Street is the road crossing. Somerset was the hub of operations on the S&C.

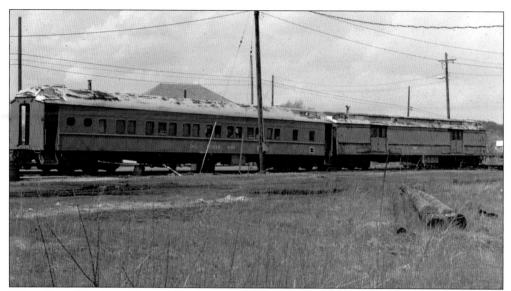

When the railroad was a little more remote to vehicular traffic, maintenance-of-way crews stayed overnight on location in former passenger cars taken out of revenue passenger service. Seen here is an example of some nice accommodations, a 12-section 1-drawing room modernized sleeper. This car had the capacity to sleep 26 people comfortably and included three bathrooms and air-conditioning. The former express car was now used as a tool and parts car. The green color is a reflection of the influence that the C&O had on the B&O after the 1964 merger of the two railroads.

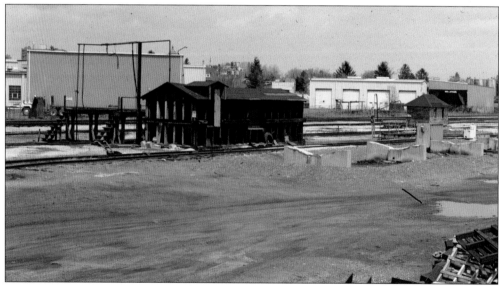

At one time, you could easily find at least a dozen locomotives here at Somerset, where a complete locomotive servicing facility was located, including a six-stall roundhouse and an 80-foot turntable. Dieselization did away with the roundhouse and turntable, but facilities were still needed for diesels. Seen here on April 27, 1991, the wooden structure is the sand house, a necessary carryover from steam days. The elevated walkway is part of the diesel transition for routine pre-trip locomotive inspection. The diesel fuel pump is to the right. The concrete foundations were for diesel fuel storage tanks. In the background, a section tool house can be seen.

These are former M-26 Class boxcars; they were the backbone of the B&O fleet for many years. As these cars became too old for interchange service and freight car capacity increased, some of these cars went into maintenance-of-way service, as seen here on April 27, 1991. These cars now were used to store tools and equipment for use by track crews. Roof running boards had been removed back in the 1960s.

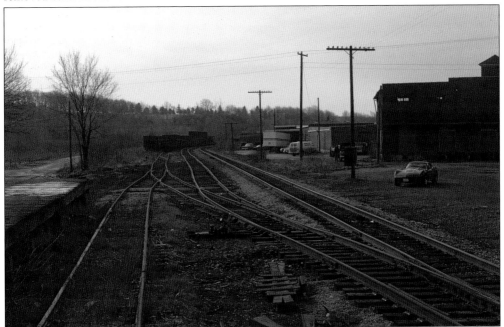

This is the north end of the Somerset yards, seen here on February 24, 1984. Main Street is just behind the photographer. The freight station was just to the left out of view. Yard tracks are to the left, with the main line on the right. We are looking south toward Rockwood. Only the main line remains today.

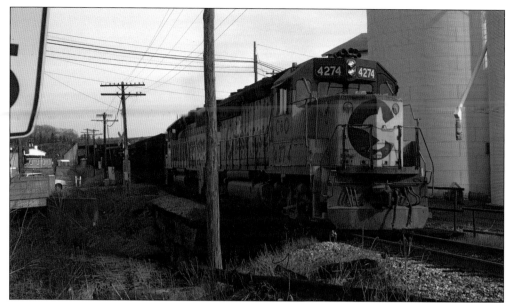

An eastbound coal train is seen crossing Main Street at the Somerset Milling. Most likely, this train came off the PW&S to the left, just past the Stoystown Road Bridge seen in the background. The PW&S was referred to as the Boswell Loop, and it was the only way to turn articulated steam locomotives on this line. With the advent of the diesel, the loop was no longer needed and was severed shortly after dieselization. The WM had mines that they served on the Boswell Loop, and for nearly 75 years WM trains routinely passed through Somerset.

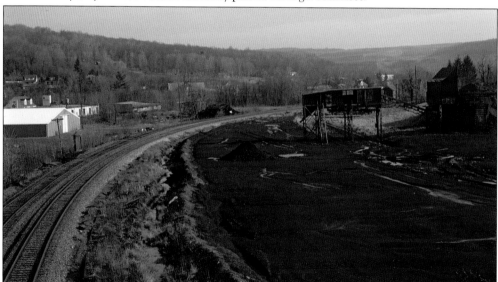

Progress is inevitable. Seen here from the US 30 bridge at Stoystown, on February 24, 1984, are the remains of the Fairview Mine collier. This was one of many mines that the railroad served that supplied coal for industry, the railroad, and home heating for decades. The need for cleaner and cheaper forms of energy, as well as the downturn in the American steel industry, saw this and many mines disappear. Coal was trucked to this location and dumped into the building at the right. A conveyor transported it to the building in the center, and from there it was dumped into railcars on two tracks.

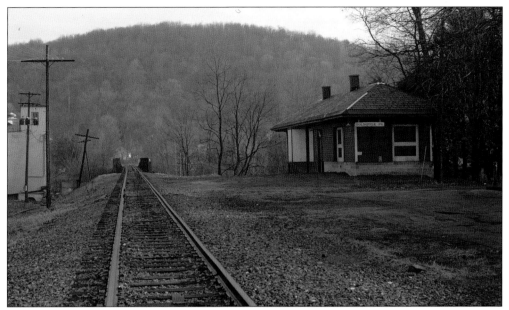

The passenger station is seen here on February 24, 1984, at Hollsopple, Pennsylvania. The view is looking railroad west, and the bridge crosses the Stony Creek River. The station had been sold to the community and moved back off the right-of-way. It would be another couple of decades before it would be restored and open to the public for display. This is a typical B&O Class C station design.

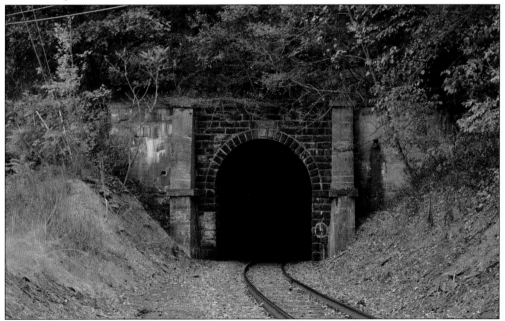

Hog Back tunnel, just south of Johnstown, is seen here on September 12, 2012. This tunnel was built in 1881, with a total of 322 feet length. Well constructed, it is one of only two tunnels on the S&C. The other one is under the right-of-way of the stillborn South Penn railroad at Geiger, just on the north side of Somerset. The tight clearances through this tunnel kept B&O articulated steam locomotives from operating into Johnstown.

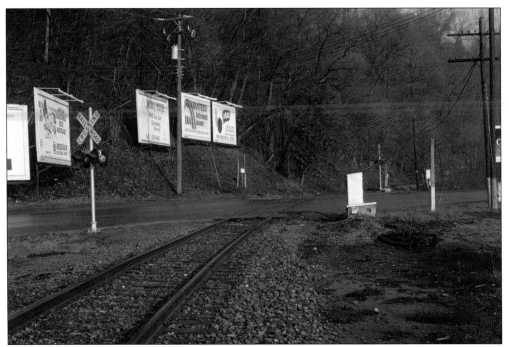

We are at Ferndale, Pennsylvania, and this is the Bridge Street grade crossing, seen here on February 24, 1984. The view looks north toward Johnstown. The billboards on the hillside were typical of rural roads in the last century.

This is the Johnstown, Pennsylvania, freight house, seen here in April 1976. The bridge in the background is Pennsylvania 56. We are at the intersection of Pennsylvania 271 and Bedford Street. Today, the freight house is merely a memory. The Stony Creek River is just to our right. This was the third freight house to serve the Johnstown area.

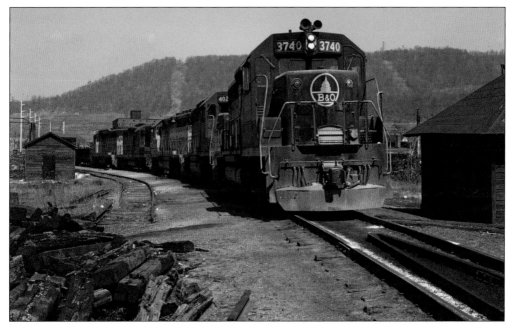

No. 3740 is about to lead an eastbound freight for Cumberland, Maryland, over the Stony Creek River Bridge. The date is April 1976, and judging by the power on the head end, there still is a fair amount of traffic between Johnstown and Cumberland. The locomotive servicing facilities can just barely be seen to the left, and a section tool house is seen at the right.

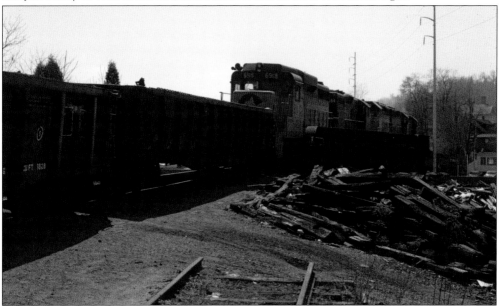

No. 3740 is crossing Stony Creek River Bridge on its way to Cumberland. The pile of decrepit ties, seen at right, were part of what was to be some of the last major track work that was done in the Johnstown yards. Thirty-plus years for ties is not uncommon. During this time, freight traffic to Johnstown would dwindle considerably, as the steel mills were closing down. Even at this time, the B&O only handled a small amount of the steel traffic in Johnstown. The lion's share was handled by the PRR.

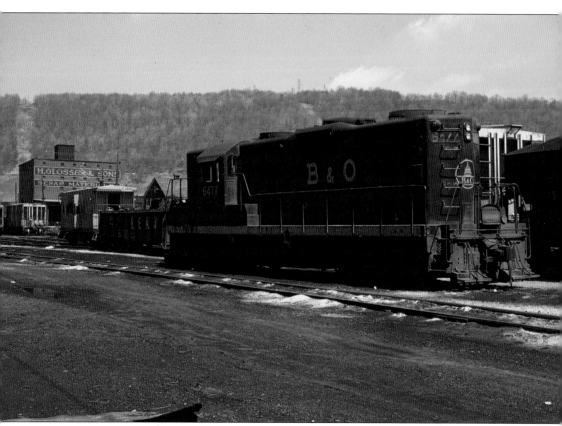

No. 6477 is also seen between shifts on the same day. This locomotive was delivered to the B&O in 1957 and was coming up on its 19th birthday! This locomotive had 1,750 horsepower, and for years this class of locomotives were the backbone of the fleet and could be found all over the system. The larger 48-inch fan on the roof indicates that this was a late model GP-9. Early models sported two 36-inch fans and had a lower profile. In the background is the new C-26a Class caboose, No. 3858, built in 1975. These were the next-to-the-last cabooses built for the railroad.

Five

THE FAIRMONT, MORGANTOWN & PITTSBURGH

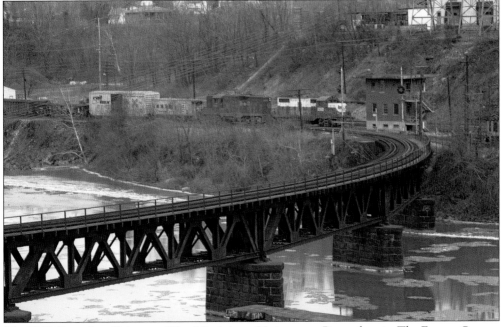

The FM&P ran from Fairmont, West Virginia, to Uniontown, Pennsylvania. The Fayette County Branch that ran from Green Junction in Connellsville to Uniontown will also be covered in this chapter. The line from Fairmont to Connellsville, which was referred to as the "Sheepskin," has a total length of 67.3 miles. Traffic was predominantly loads railroad-west and empties east, most of which was coal from around the Fairmont area. Since 1916, the Western Maryland Railway had trackage rights from Bowest Junction to its mines on the south side of Fairmont, and for years Western Maryland power was at the head of daily coal trains on the line. When radios were introduced on the B&O, the FM&P was its proving grounds. The FM&P saw its last passenger train on September 13, 1986, in the form of an excursion train from Grafton to Connellsville. This is Green Junction, where the FM&P (technically, here, the Fayette County Branch) diverges from the Pittsburgh Division Main Line, crossing over the Youghiogheny River. On January 13, 1980, a pair of GP-9s are working as hump units in the east end of the Connellsville Yards at WH Tower. This is the second bridge for the FM&P, and the top of one of the bridge piers can be seen in the bottom center of the photograph.

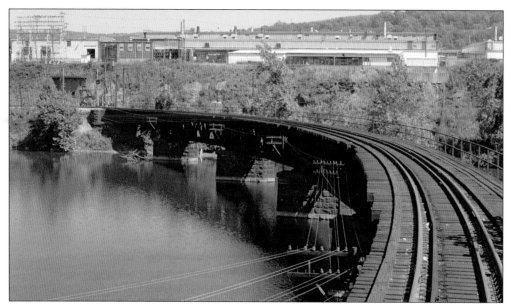

On September 13, 1986, I was privileged to be on a fall excursion from Grafton to Connellsville. This photograph was taken on the return trip to Grafton from the observation car. This was to be the last passenger train on the FM&P. Little of the Connellsville yards can be seen. However, we get an excellent view of a different approach to getting telephone and telegraph lines over the river, by mounting the poles on the bridge piers and mounting the cross beams on the right side to the pole.

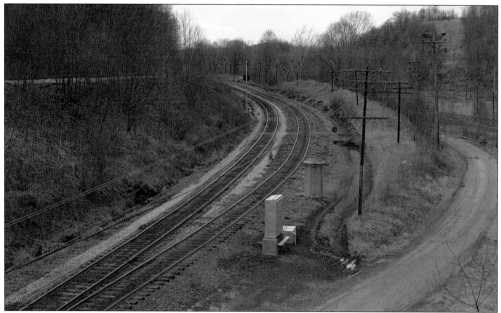

This photograph was taken from the Western Maryland interchange with the Pittsburgh & Lake Erie Railroad on January 13, 1980. The tracks to the left are the WM tracks from Cumberland, Maryland. The tracks in the foreground belong to the B&O. Just around the curve to the left is where the B&O and the WM meet and the WM shares trackage rights into Fairmont, over the FM&P.

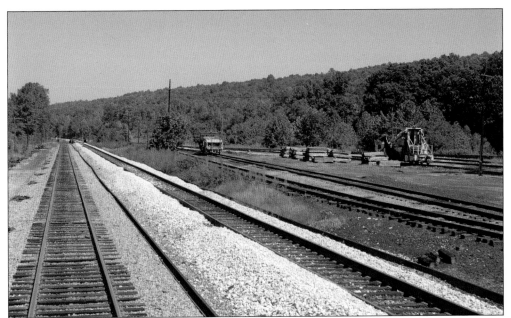

Welcome to Bowest Junction. The name is a simple derivative of two railroads, the B&O, and the Western Maryland, that met and interchanged freight here. Pictured here on September 13, 1986, is what was left of the yards where B&O, P&LE, and WM trains were passed off to each other. At one time, a locomotive servicing facility, mostly for WM engines, was located to the right of the double-track main line.

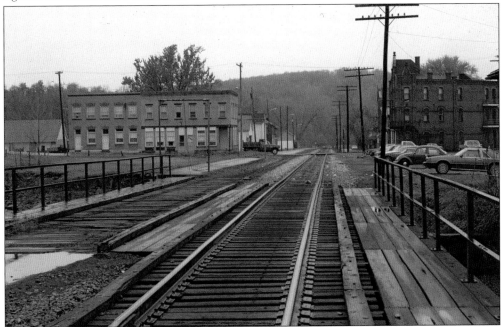

Dunbar, Pennsylvania, is pictured on May 4, 1988. In this scene looking north, we see the main line bridge over Dunbar Creek. The former eastbound main line has been gone for quite some time as a result of dwindling traffic. The asphalt slab between the end of the bridge and the dump truck is what remains of the passenger station platform that served the town.

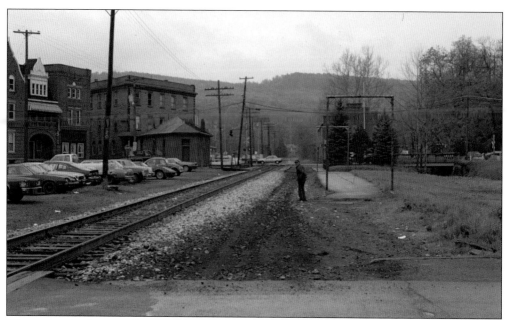

We are now looking south toward Uniontown, Pennsylvania. Ridge Street is in the foreground, and the automobile in the background is crossing Woodvale Street. We are at milepost 61/20, as indicated on the telegraph pole at the left. In railroad terms, that puts us 61 miles and 20 telegraph poles (via the railroad) west of Fairmont, West Virginia, the start of the FM&P subdivision. The former passenger station was located on the left where the automobiles are parked.

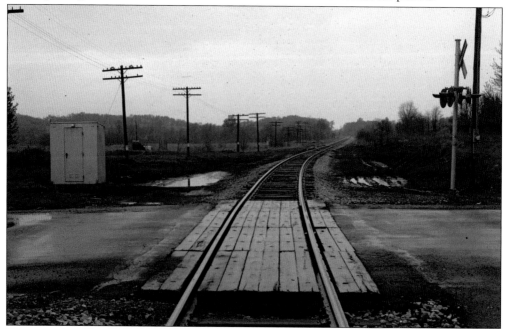

We are at the Mount Braddock Road grade crossing, in Mount Braddock, Pennsylvania, looking south. Uniontown is six miles ahead. The date is May 4, 1988. In the background, to the left of the main line, the railroad kept a 56-car siding here for storage. A small passenger station was once located at this site.

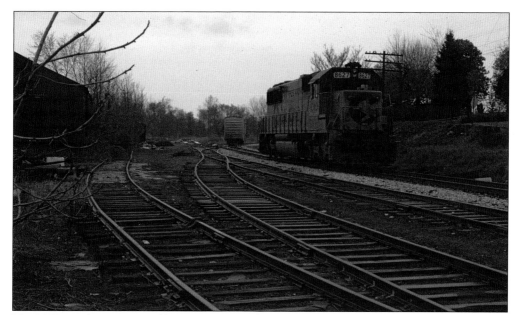

No. 8627 was the newest and largest power on the road. How it managed to be pressed into local service is a mystery, but here it is on May 4, 1988, at Uniontown, Pennsylvania, performing switching duties in the yards in and around town.

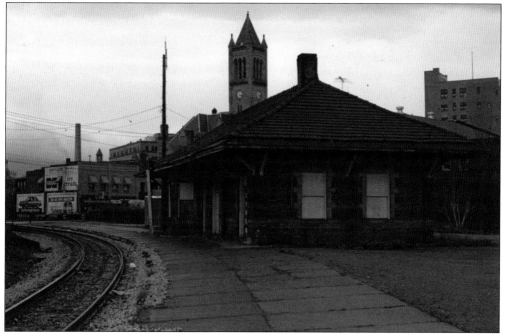

According to the clock tower in the background, this May 4, 1988, photograph was taken at 4:20 p.m. This is the once proud B&O combination passenger/freight station that served Uniontown, Pennsylvania, but it has been about 30 years since any passenger trains have stopped here. Maintenance-of-way forces now use the station for storage. The ornate brickwork around the doors and windows was part of the opulence of architecture from early in the last century, as was the Spanish tile roof, which was not standard for the B&O east of the Ohio River.

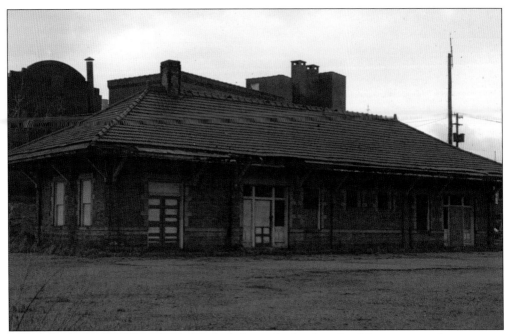

This is the street side of the station. On the left was the freight side of the station, with passengers served on the right. The use of yellow bricks and granite in construction was also an abnormality for the B&O. In its day, Uniontown commanded a great deal of industrial influence that is hard to imagine today.

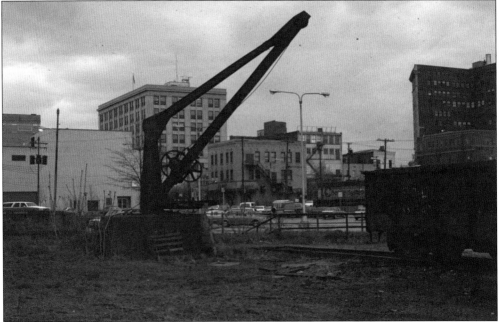

A relic from the past! This is a jib crane. Its purpose was to load and unload flatcars and gondola cars, and it was operated completely by hand. This technology goes back well over two centuries. It was rated at a capacity of 44,800 pounds. At the time of this May 4, 1988, photograph, it probably had not been used in nearly three decades.

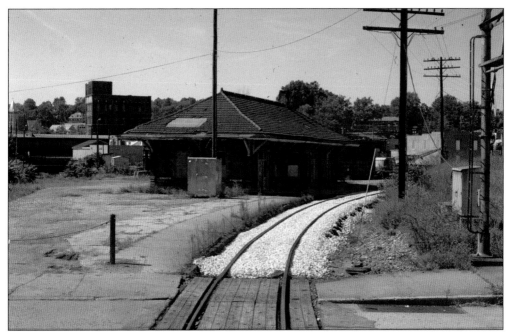

This September 13, 1986, photograph, taken from the vestibule of an excursion train, shows the passenger end of the station. The station is an example of a rectangular structure with a curved platform. Pictured behind the left corner of the building is the jib crane from the previous photograph. At the right of the building is a rail-mounted crane of less capacity.

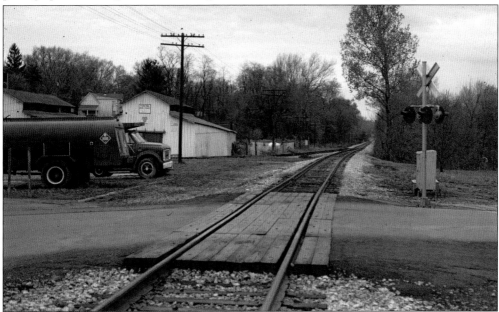

This is the Sheldon Avenue grade crossing in Fairchance, Pennsylvania, on May 4, 1988. The fuel trucks are located where the passenger station used to be, as is evident by the concrete foundation strip in front of the trucks. The use of timbers between the tracks was the typical grade crossing arrangement designed by the B&O Railroad for vehicular and pedestrian crossings and can be found in standard plan drawings going back to 1906.

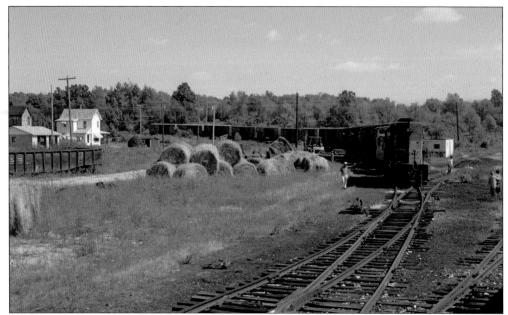

We are at S&M Junction on the morning of September 13, 1986. The boxcars on the left are on the Smithfield & Masontown Branch line that runs 8.3 miles to Leckrone, Pennsylvania, and interchanges with the Monongahela Railway. No. 3563 is in charge of this local that is working the branch. The track scale is in the building to the right of the locomotive. The excursion train from which the photograph was taken was on its way to Connellsville (to the right).

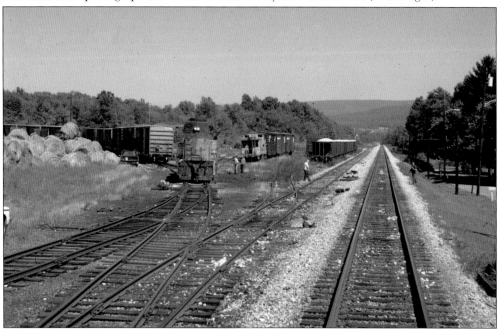

On the return trip to Grafton, as we passed by S&M Junction, No. 3563 was now working the track scale. Note that the caboose and boxcars are on top of the track scale. By this date, the Smithfield & Masontown Branch line's days were numbered. Little did I know that in less than 10 years, the FM&P would share the same fate.

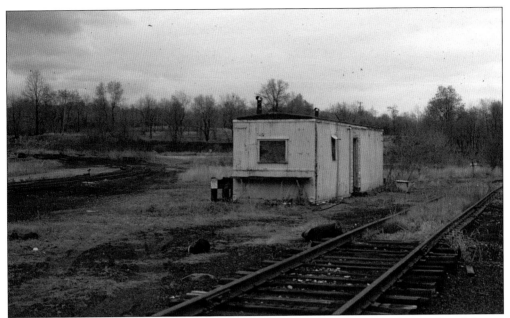

By May 4, 1988, there was no discernible sign of activity at S&M Junction. This track scale house was built from an old M-26 boxcar. The first scale house was of wooden construction, and when the time came to replace it, the small structure was torn down, and the boxcar body set in its place. This was just another example of how the railroad reused its resources. The scales here had a capacity of 300,000 pounds.

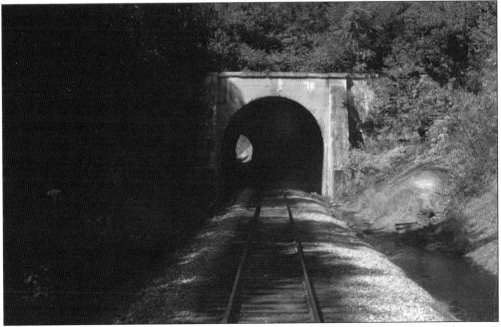

This is the west portal of Morgan tunnel on September 13, 1986, at Outcrop, Pennsylvania. It was built in 1892–1893, with a total length of 410.4 feet on a two-percent curve, with a horizontal width of 26 feet, 6 inches. In 1916, it received a concrete facade. Some deterioration of the concrete has occurred over the past 70 years.

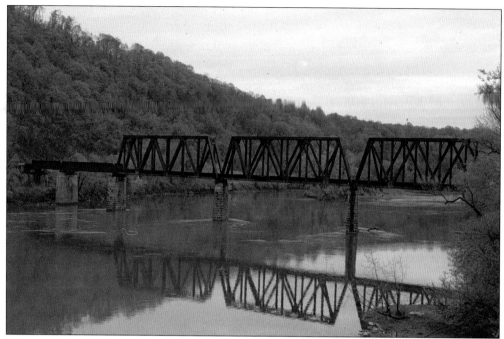

The B&O crossed the Cheat River at Point Marion, Pennsylvania, on this beautiful six-span bridge. On September 13, 1986, our excursion train had just passed over it. Today, the bridge, like the FM&P, is only a memory, and only its piers remain.

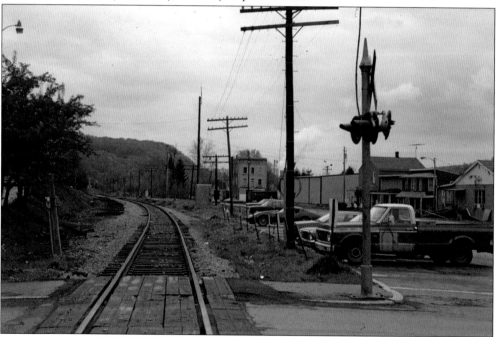

This is downtown Point Marion, Pennsylvania, on May 4, 1988. The passenger station was located on the right of the tracks just behind the second telephone pole. At this point, we are 32 miles from Connellsville and 38 miles to Fairmont. The grade crossing in the foreground is US Highway 119.

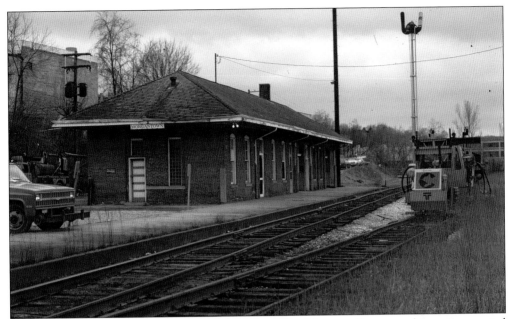

It is February 20, 1984, and we are at Morgantown, West Virginia. For years, this station carried the telegraph call letters MN. Morgantown was also the west end of the M&K (Morgantown & Kingwood Branch), which joined the FM&P just out of sight to the right. The train order signal, seen at the right, was to let train crews know if it was necessary to make a stop here at the station.

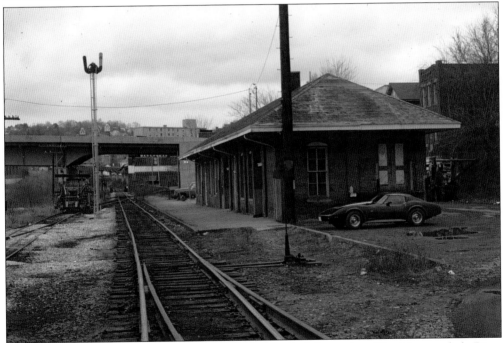

This February 20, 1984, photograph shows the east end of the station. The Monongahela River is just to the left. We are looking north to Connellsville at this point. That is the Pleasant Street Bridge in the background. The Corvette in the parking lot was my everyday transportation.

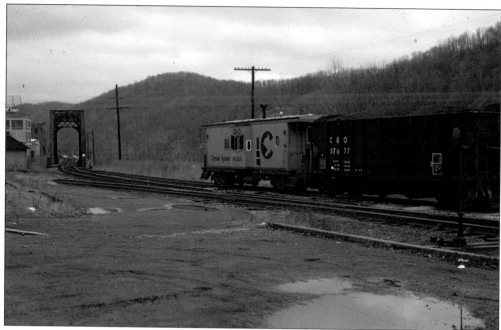

Just east of the station is the M&K, seen here with the track running off to the lower left. The FM&P continues over the bridge to Fairmont. The caboose is part of a local working in town. Today, this scene is part of a rails-to-trails that occupies much of the former FM&P. This photograph was taken on February 20, 1984.

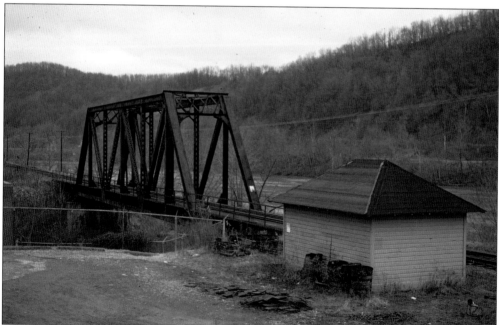

This is the main line crossing of Deckers Creek, which empties into the Monongahela River. The Monongahela Railroad right-of-way can be seen on the other side of the river. The M&K Branch heads east on this side of Deckers Creek in its journey to Kingwood and Rowlesburg. The structure in the foreground is a section tool house.

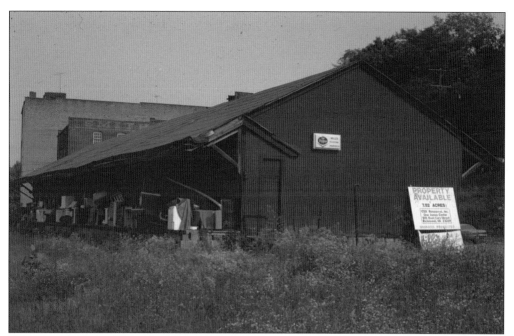

For years, this was the freight house in Morgantown. The date is October 9, 1988, and CSX is trying to sell the building. This is obviously the track side, and the other side is for truck traffic. It is evident that it has been years since any freight cars have been unloading freight at these platforms. This location was called "Decker siding" by the railroad.

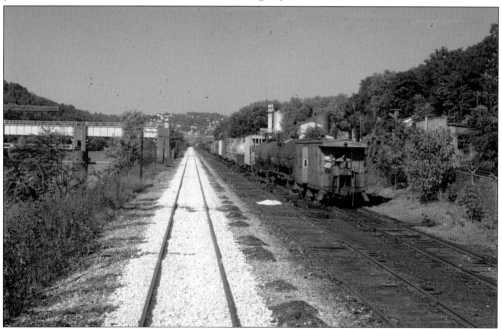

While returning from Connellsville on our excursion trip, we took priority on the line, which required all traffic to take siding for us to pass. This resulted in a westbound freight being put "in the hole." This event occurred on September 13, 1986. At this time, there was still a bit of traffic on the FM&P. The freight yard had a capacity for 108 cars.

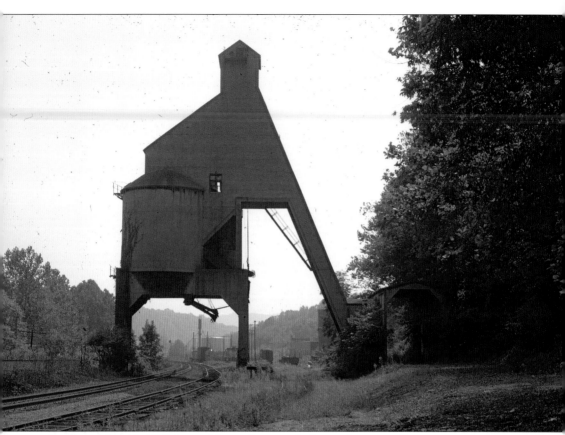

On September 10, 1978, I was able to photograph the coal tower in Fairmont at the east end of the FM&P. This structure was built in the early 1920s, replacing a wooden coal trestle. At one time, it served four tracks. The track to the left is the FM&P to Connellsville, the next track served the Paw Paw Branch that connected with the Monongahela Railroad, and the third track was for the locomotive facilities. A fourth one, taken up, was between the station base and the conveyor. There would also have been a track into the unloading shed on the embankment.

Six

The Wheeling, Pittsburgh & Baltimore

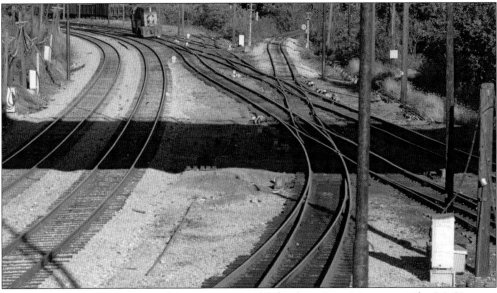

The Wheeling, Pittsburgh & Baltimore connected Wheeling, West Virginia, to the B&O's main line at Glenwood, Pennsylvania, five miles east of Grant Street station. The line was an important bridge for traffic from western Pennsylvania and western New York State to Cincinnati and St. Louis. For decades, passenger trains traveled this route from western New York to Louisville. By the time I got the opportunity to record and explore what was left of this line, it had already been severed between Washington, Pennsylvania, and Elm Grove, West Virginia, and was served by local freights out of Glenwood yards. In the day, without this important connection, traffic would have been slowed down by as much as a day, having to travel farther east or farther northwest to its destination. Passenger service would not have been possible as a competitive force between Buffalo and Louisville without it! The introduction of the Interstate Highway Act, airplane service, a post–World War II economy's move away from coal as a major source of traffic, and deregulation led to the other subdivisions' demise. Above is the west end of the Glenwood Junction yards looking east on October 11, 1986. The track on the left is the main line to Connellsville. The tracks in the foreground connect the main line and yards to the WP&B (Wheeling Pittsburgh & Baltimore) in the upper right to Wheeling. The parallel diagonal tracks connect the yards to the main line.

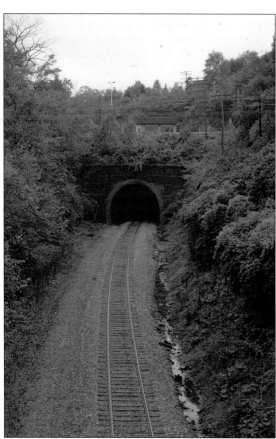

This is the west portal of Whitehall tunnel at milepost 5.4 from Glenwood Junction, pictured on October 13, 1986. This was once a double-track line. Built in 1901, this tunnel is 1,630 feet long.

We are at Bruceton, Pennsylvania, on October 13, 1986. The crooked track arrangement belongs to the B&O, while the tracks overhead belong to the P&LE. The B&O passenger station platform stood on the left of the tracks, with the station behind it. The telegraph call letters here were KY.

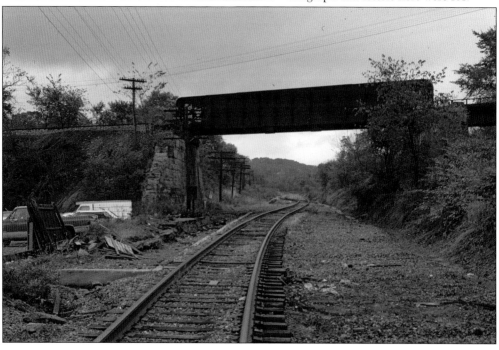

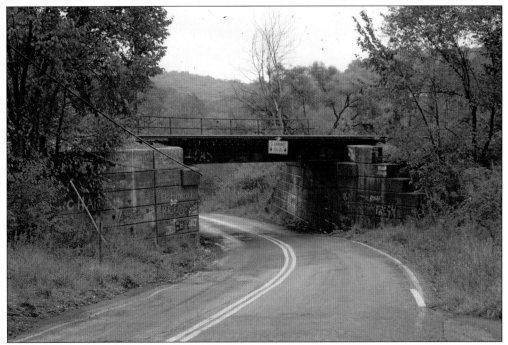

On October 13, 1986, I visited Snowden, Pennsylvania, and this little bridge over Piney Fork Road. This little deck plate bridge was more than sufficient to carry railroad traffic, but with a vertical clearance of only 11 feet, 2 inches, vehicular traffic below was severely restricted.

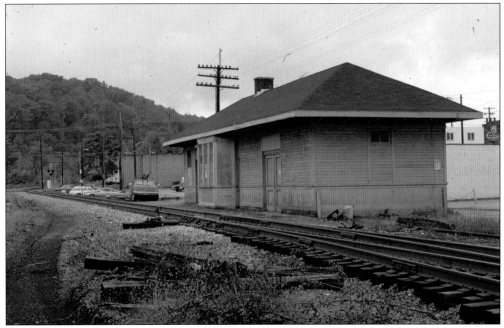

This is the combination station at Finleyville, Pennsylvania, on October 13, 1986. The switch is for a passing siding located here. This location is 12.9 miles from Glenwood Junction. The telegraph letter for this location was F. At one time, there was double track on the line here. The lack of traffic caused the line to be single-tracked.

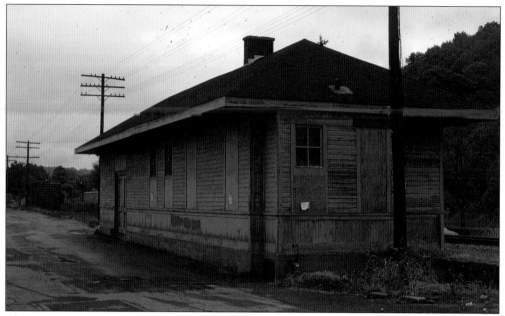

This is the passenger end of the combination station at Finleyville, Pennsylvania, on the street side. Basically, this is a standard design for a Class C combination station. Often, slight changes were made with regards to window and door locations to better suit the needs in a given location. At this time, the station was occupied by the maintenance-of-way forces. It had been decades since the last passenger train stopped here.

On this day, a lone Railbox boxcar with Union Pacific reporting marks has been spotted on the siding here in Finleyville, Pennsylvania. Though the car is located at the station, the freight was for a local business. This track is called a team track, for businesses that did not have enough rail business to warrant their own siding. It was used by many businesses in the community.

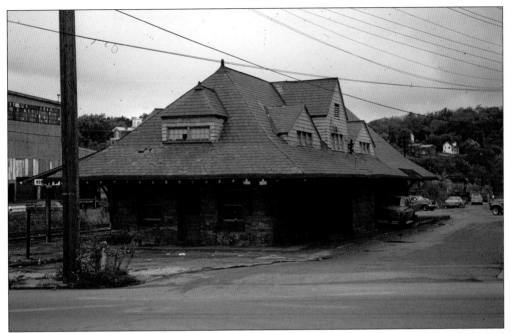

Washington, Pennsylvania, station, seen here on October 13, 1986, was obviously built to a higher standard than most stations; note its cut stone construction. Interestingly enough, at this time, the parking lot still retains its brick pavement. While characteristic of the era in which it was built, most often such parking lots and streets around town were eventually asphalted over.

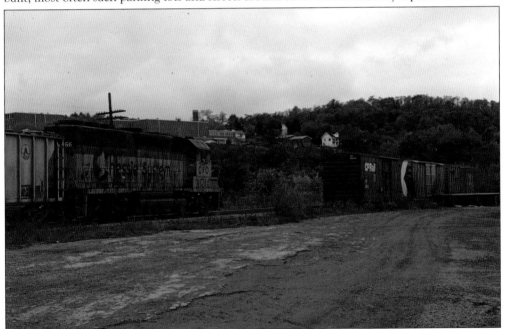

No. 4066 was the power this day on the local from Glenwood. At this time, the line only ran as far as Washington and had been severed just to the west of town. The crew was not on board at this time, as they were out to lunch at the local diner nearby. This was a common practice. The team track here in Washington was bustling with activity, as can be seen with the three boxcars.

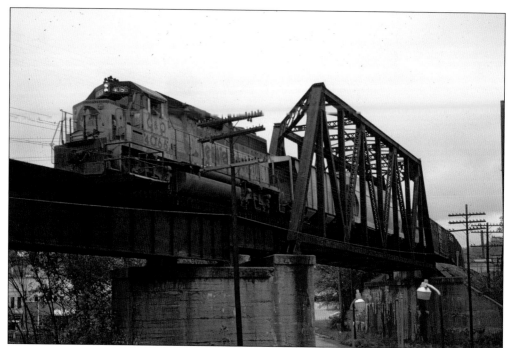

High above South Wade and Moore Avenues, and with lunch over, we get a friendly wave from the fireman of No. 4066 as the train passes through a truss bridge and over a plate girder bridge on its way back to the Glenwood yards. The date is October 13, 1986.

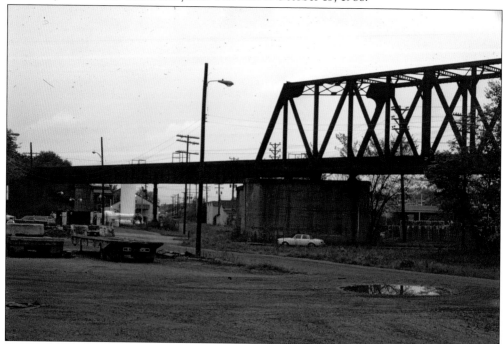

A series of deck plate and Pratt truss bridges span the breadth of both South Wade and Moore Avenues in downtown Washington, Pennsylvania. At one time, twice a day, this bridge was host to a daily passenger train running from Pittsburgh to Louisville.

This view of the passenger station platform at Elm Grove looks west to Wheeling, which is a mere 3.5 miles away. The date is June 20, 1986, and already the line has been cut between here and Washington, Pennsylvania. This view shows us the typical B&O station platform that was constructed with bricks. Not only railroad platforms were built this way; roads early in the last century also were constructed using bricks.

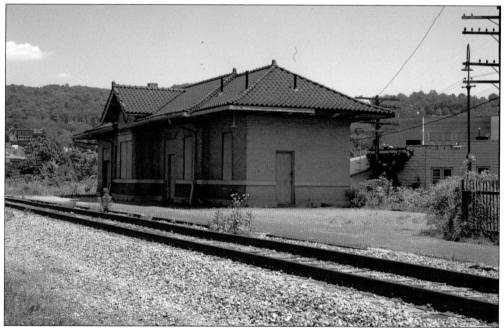

This is the combination freight-and-passenger station that served Elm Grove. Behind, below, and at the right is US Highway 40. Even for a masonry-constructed structure, the use of a cream-colored brick was unusual, as was the Spanish-style roof tile. The last time a passenger train stopped here was in the early 1960s, with the discontinuance of train No. 233/238.

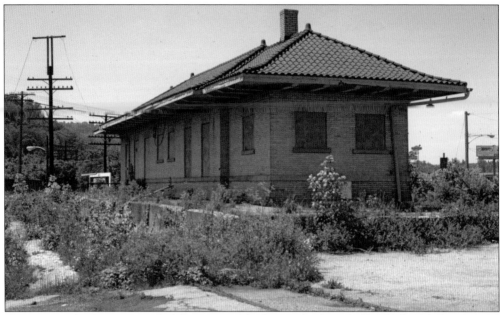

Here, we see the passenger end of the station, which is easily identified by the boarded up waiting room windows and the chimney, which was used to heat the station. This is the street side of the station. When this station was still seeing freight service, there was a single track in front of the platform, which is now covered in weeds. This station had the telegraph call letters NA and is seen here on June 20, 1986.

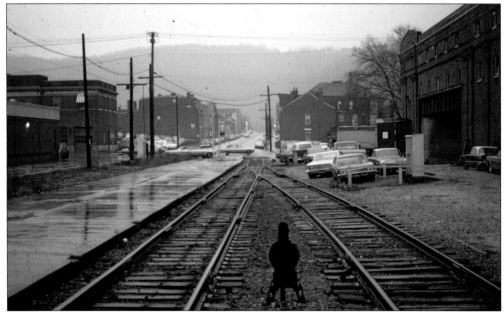

On a cold, damp and dreary day in February 1974 we take a final look east at the WP&B. Sixty-two miles ahead is Glenwood Junction. At this time, the line still saw regular traffic. The trackage is about to enter Wheeling's Eighteenth Street and start a short two-block trip with vehicular traffic, which is always a challenge for both the train and automobiles. Even worse was the loud sound of a steam whistle when your house or business was only 20-plus feet away.

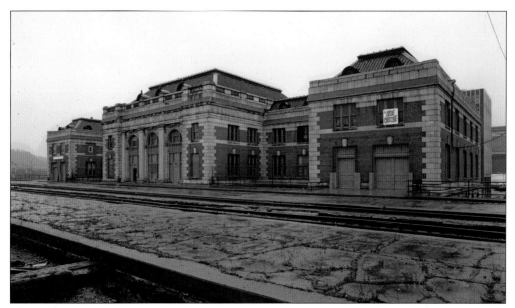

This is the Wheeling passenger station, pictured in February 1974. The overcast day epitomized the fate of one of the B&O's busier passenger stations. Once, passenger trains left here on five routes. At one time, the top floor hosted the Wheeling Model Railroad Club. The telegraph call letter here was Q. Today, the station survives as the West Virginia Northern Community College, a branch of West Virginia University, but the elevated station platform, visible here in the foreground, which is a full story above the streets below, is long gone.

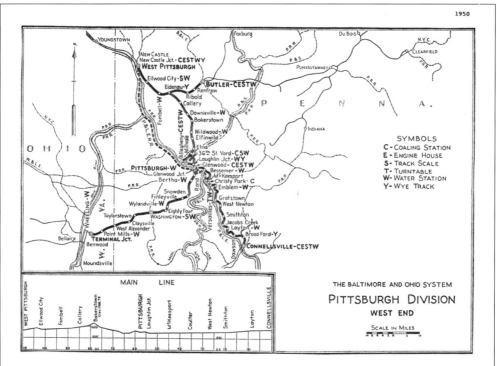

Pictured above is a map of the West End of the Pittsburgh Division.

DISCOVER THOUSANDS OF LOCAL HISTORY BOOKS
FEATURING MILLIONS OF VINTAGE IMAGES

Arcadia Publishing, the leading local history publisher in the United States, is committed to making history accessible and meaningful through publishing books that celebrate and preserve the heritage of America's people and places.

Find more books like this at
www.arcadiapublishing.com

Search for your hometown history, your old stomping grounds, and even your favorite sports team.